Lake George

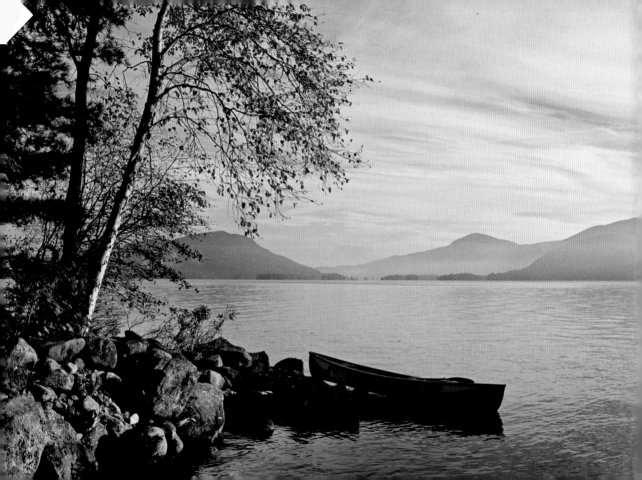

Lake George

CARL HEILMAN II

BOOKS

North Country Books, Inc. • Utica, New York

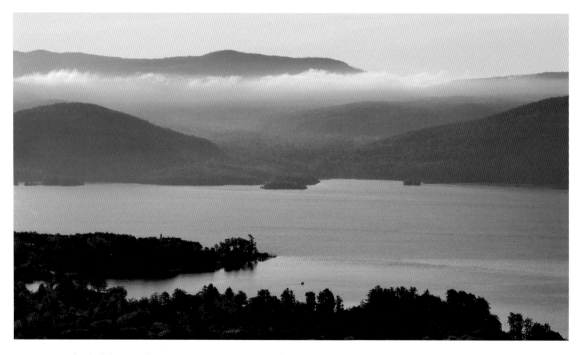

above Green Island, Shelving Rock Mountain, and Sleeping Beauty from a Bolton Landing overlook
previous page View over a Hornbeck canoe to the Narrows from Clay Island
following page Looking north from Diamond Point

Contents

Introduction

My earliest memory of Lake George is of moving slowly through village traffic while en route to our summer camp in Brant Lake. There was no Adirondack Northway at the time, and all traffic heading north into the Adirondacks had to pass through Lake George on Canada Street. In the late 1950s the entire trip from our home in Lancaster County, Pennsylvania, to the Adirondacks was about thirteen hours of traveling over narrow two-lane highways. We'd go through the Poconos and the Catskills, past Albany and Clifton Park. My parents pointed out features along Route 9 in Saratoga and Glens Falls, and excitement would build as we passed Animal Land and Storytown (now the Great Escape), since we knew the long trip was almost over. And then we'd hit the summer traffic of Lake George Village.

The traffic cops always did their best to keep cars moving smoothly through town among the throngs of pedestrians already enjoying their summer vacation. We would pass the Tiki, Gaslight Village, Fort William Henry, and the Jolly Roger, knowing that we'd be back at some point during our vacation to visit Lake George and enjoy the energy of summer in the village. We'd have pizza and ice cream, take walks along Beach Road, go to at least one amusement park, and visit Fort William Henry. I believe I still have one of the musket balls the guides hand-molded and gave to kids who toured the fort.

We often went to Lake George Village on the Fourth to enjoy fireworks over the lake. The first show of the evening was the wonderful display of twinkling lights from the boats jockeying for position to watch the fireworks from the water. After a spectacular display, the boats would honk their horns out on the lake, while along the shoreline the traditional oohs and aahs from thousands of spectators could be heard. The finale always brought raucous applause and more horn honking, and then the boat lights would spread out in all directions until the surface of the water was quiet and dark again.

In some ways Lake George has changed very little since that time—the beauty, charm, and wildness of the lake draw visitors back to the area year after year. The faces change, and cars, motorcycles, and buses have replaced the trolley and horse-drawn stage, but visitors continue to be drawn to the magic of this special place, just as they have for many generations.

The thirty-two-mile-long lake varies from one to three miles in width, has over 300 islands, and reaches a maximum depth of 195 feet. The Narrows, the most dramatic section of the lake, is flanked on each side by wild mountains whose steep, rocky flanks rise as much as 2,300 feet above the water.

Many of the mountains surrounding the lake are state land, protected as "Forever Wild" by the New York State Constitution, and are as wild today as they were centuries ago when Native Americans traveled and camped throughout this region for summer hunting and fishing.

In 1646 Father Isaac Jogues, the first European explorer to see Lake George, christened the lake Lac du Saint Sacrement (Lake of the Blessed Waters). The lake was renamed in honor of King George by Sir William Johnson about a hundred years later.

In the 1700s this area was an important outpost in both the French and Indian War and the Revolutionary War. Battles were fought at Fort William Henry, and the capture of Fort Ticonderoga on May 10, 1755, by

Ethan Allen, Benedict Arnold, and the Green Mountain Boys was the first victory of the American Revolution.

In the 1800s the region became a major vacation destination. Tourists from New York City and elsewhere made their way up the Hudson River Valley by steamboat, train, and stagecoach to reach the growing number of elegant hotels along the lake's shoreline, including The Sagamore and Fort William Henry.

Around the beginning of the twentieth century, the Lakeshore Drive area south of Bolton Landing evolved into the famed Millionaire's Row. Here an elite few from down-state built palatial thirty-room frame and stone summer "cottages" along the shoreline. A few of the original mansions still remain today. Automobiles and new roads soon brought a great influx of new vacationers throughout the 1900s, many of whom built family camps along the shores of the lake. Among the visitors were numerous musicians and artists—including Georgia O'Keefe, photographer Alfred Stieglitz, and several Hudson River School painters—who found inspiration in the splendor and wonder of the lake and mountains.

While the beauty of the area has not changed, there has been significant

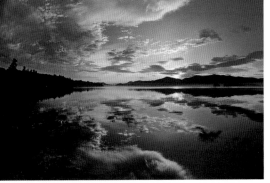

growth around the lake with a resultant impact on the environment. Lake George has some of the cleanest water in the state, but development throughout the watershed has greatly contributed to sedimentation and water quality concerns. Development issues, storm water runoff, lawn chemicals, and non-native invasive species are a few of the ecological issues facing Lake George today.

There are numerous groups working to protect the environmental quality of the Lake George basin, including the Fund for Lake George, the Lake George Waterkeeper, the Lake George Association, and the Lake George Land Conservancy. They are are all working to help safeguard the watershed, regulate sustainable growth, and protect the rich environmental and historical character of the Lake George Basin. With a conscientious effort on the part of everyone who visits and lives around the lake, it will be possible to maintain the unique qualities of Lake George and its "blessed waters" for many generations to come.

Carl E. Heilman II

Lake George Village

Fort William Henry • Lake George Battlefield Park • Million Dollar Beach
Prospect Mountain • Shepard Park • Usher Park

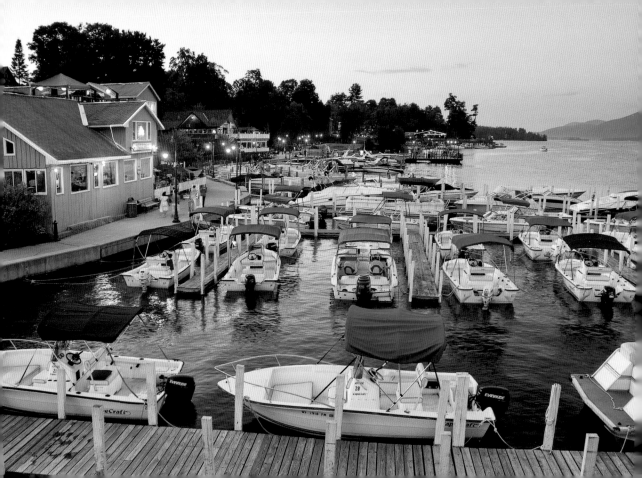

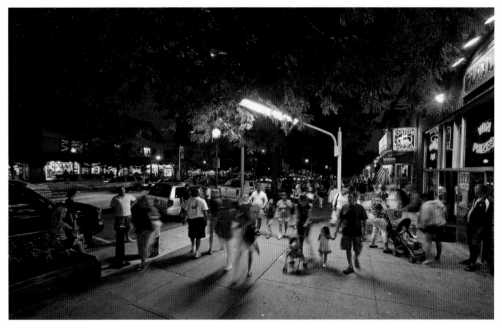

above *Canada Street at twilight on a summer night*
opposite *Looking north to Shepard Park from the top deck of the* Horicon
following page *Lake George Village and southern Lake George from a shoulder of Prospect Mountain*
previous page *Rainbow over the Blais Park and the town boat docks from the Vistors' Center*

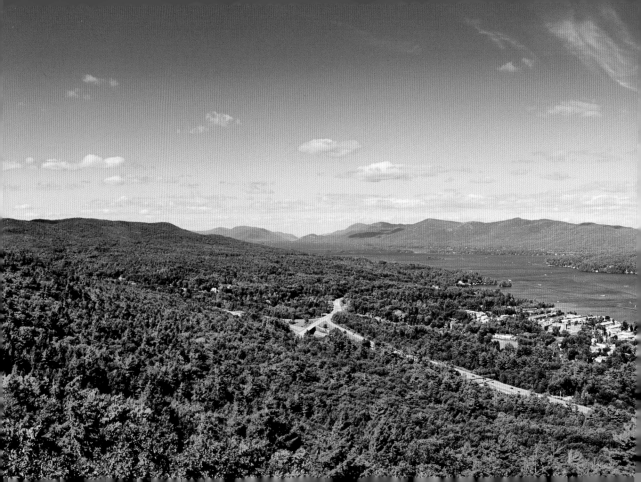

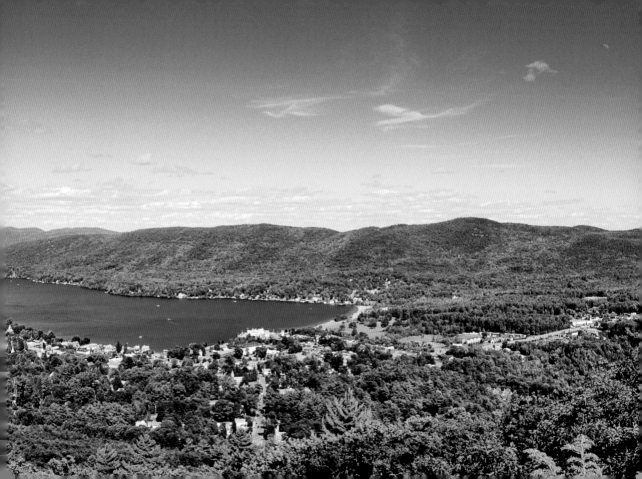

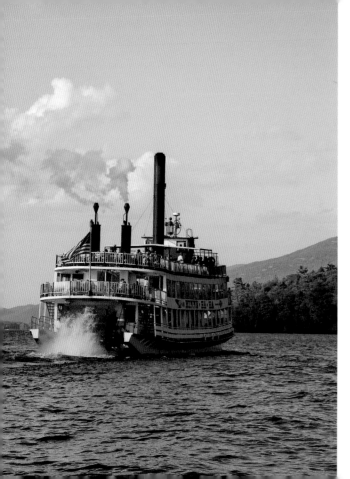

left *Tour boat* Minne-ha-ha *near the Wiawaka
Holiday House dock*
opposite *Mallard on Lake George*
following page *Sunrise light from along Beach Road*

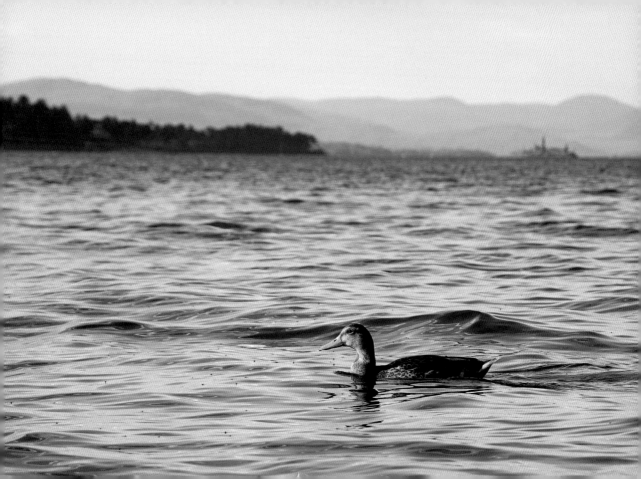

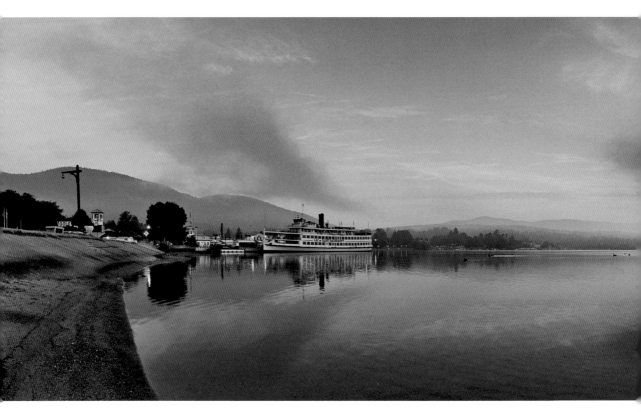

16

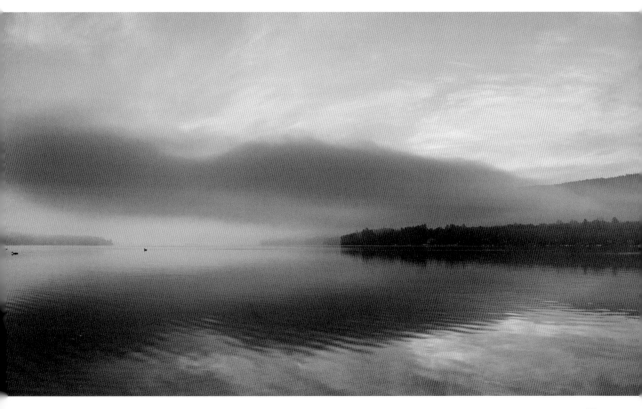

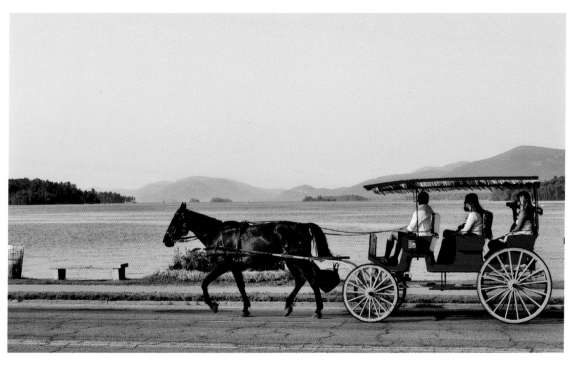

above Horse and carriage along Beach Road
opposite Entrance to Million Dollar Beach

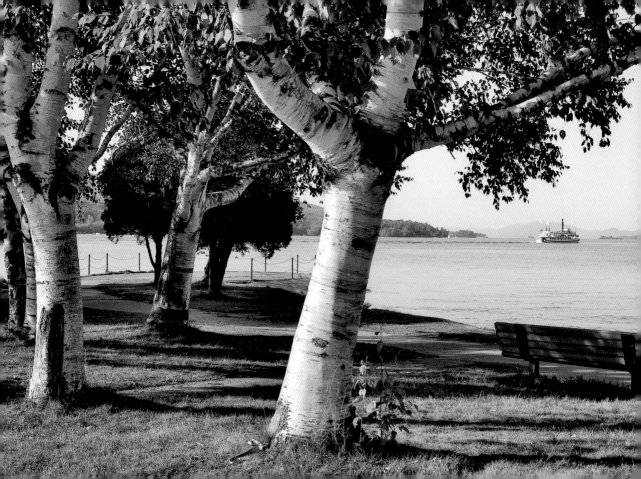

View up the lake near Million Dollar Beach

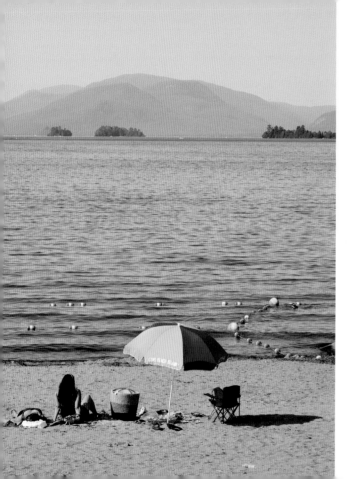

left *Looking north from Million Dollar Beach*
opposite *Aerial view of the beach*

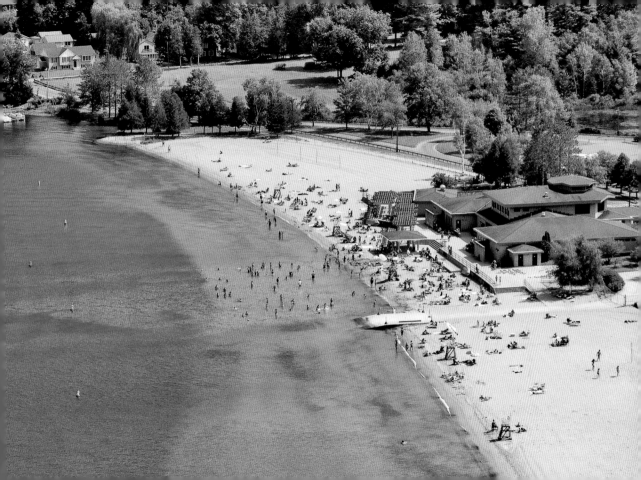

right *Adirondack chairs along the shore by Beach Road*
following page *The village of Lake George at twilight*

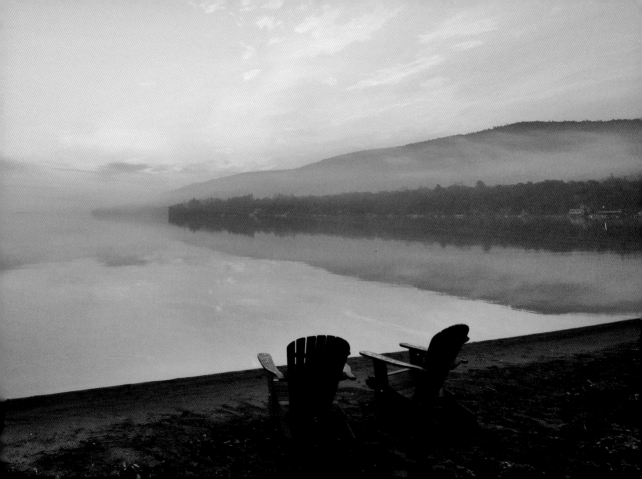

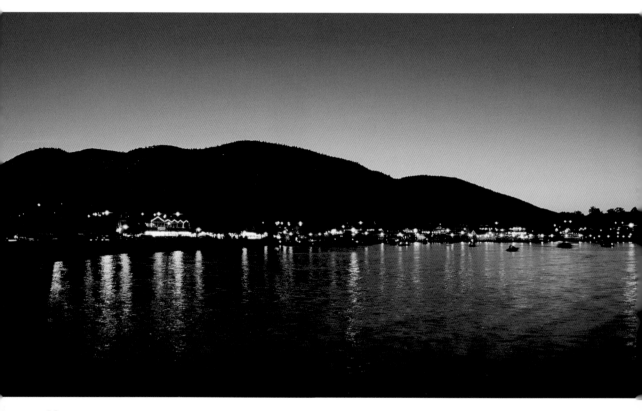

above and opposite *Adirondack Nationals Car Show held each September in the village*

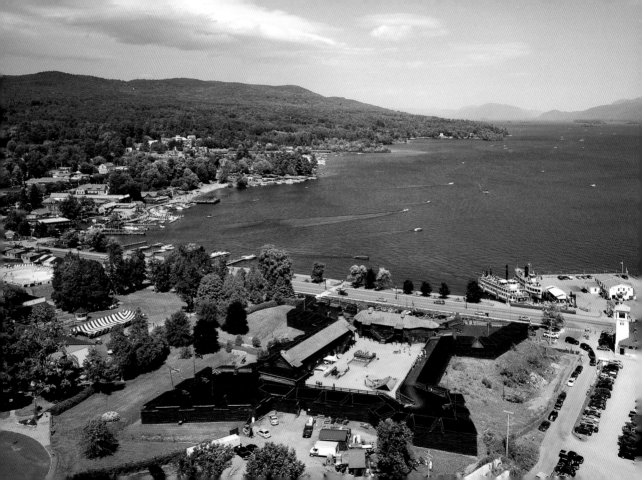

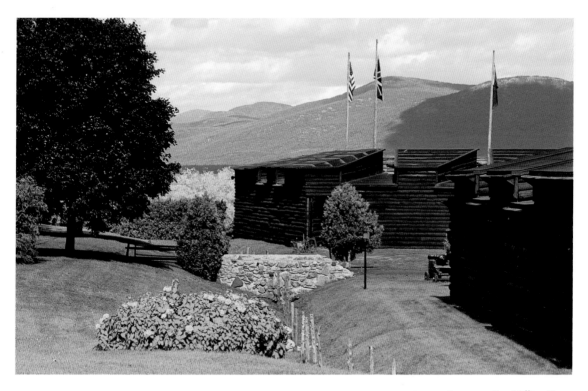

above and opposite *Fort William Henry*

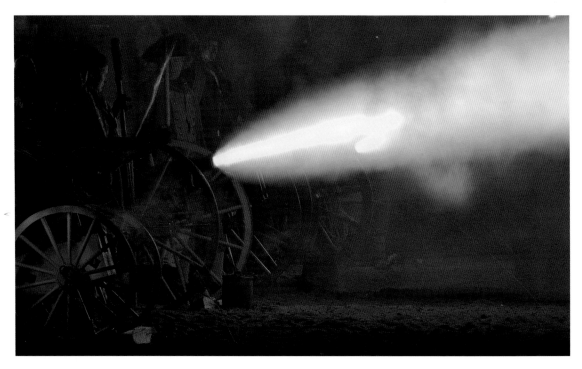

above *Cannon firing along Beach Road during the 2007 French and Indian War reenactment of the siege of Fort William Henry*
opposite *Fireworks over bateaux replicas during the reenactment*

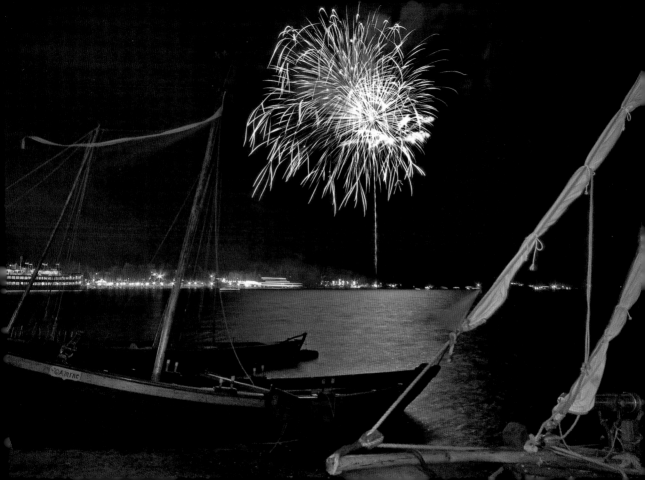

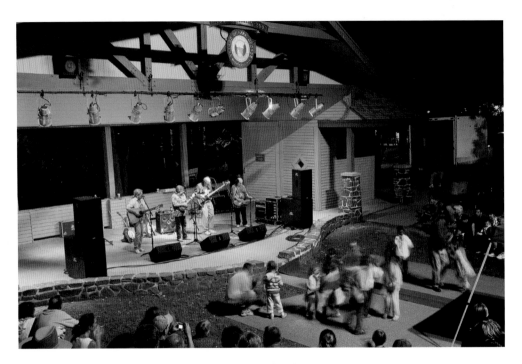

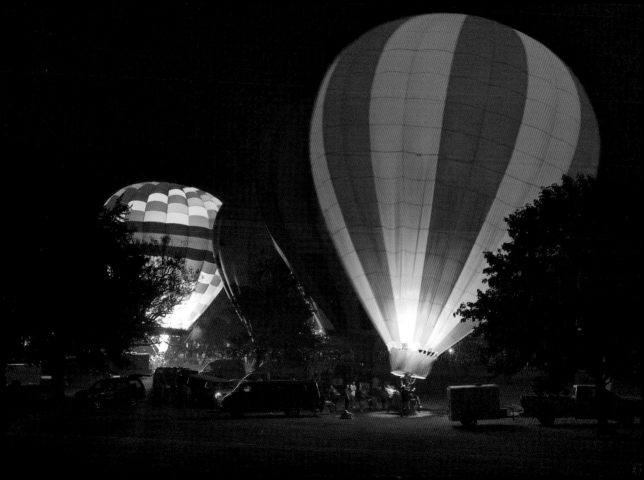

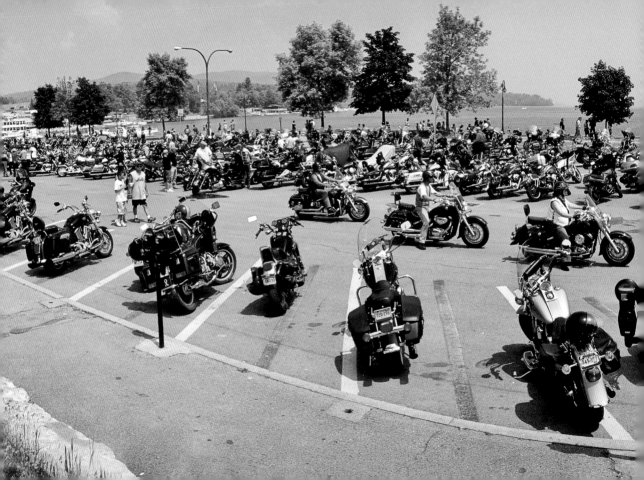

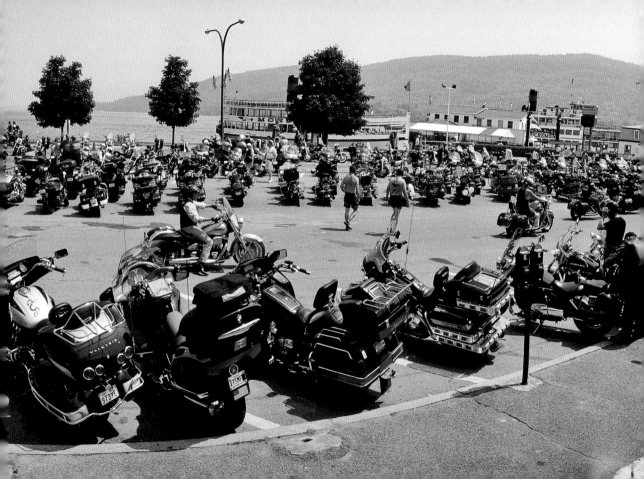

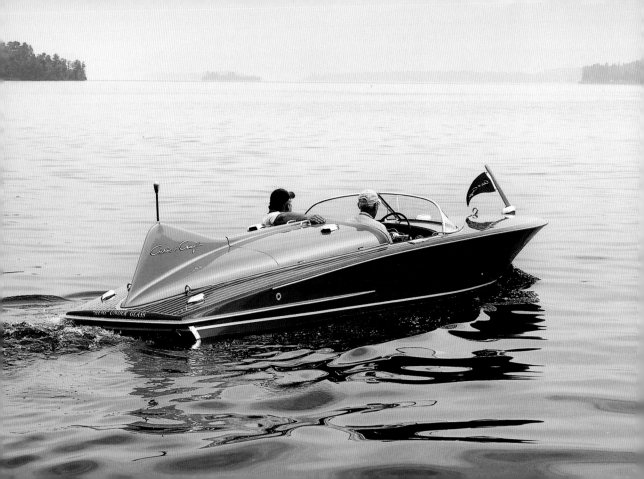

right and opposite *Antique and Classic Boat Society*
2007 International Meet in Lake George

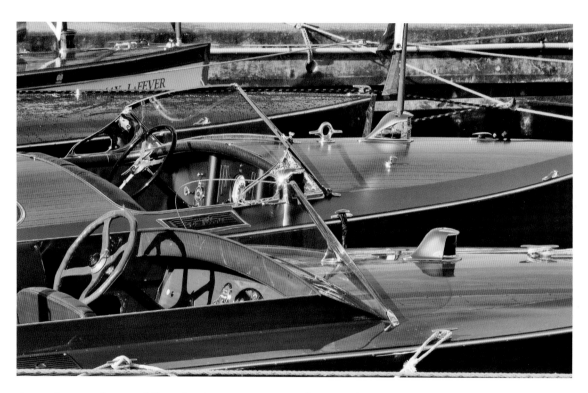

above and opposite *Antique and Classic Boat Society 2007 International Meet in Lake George*

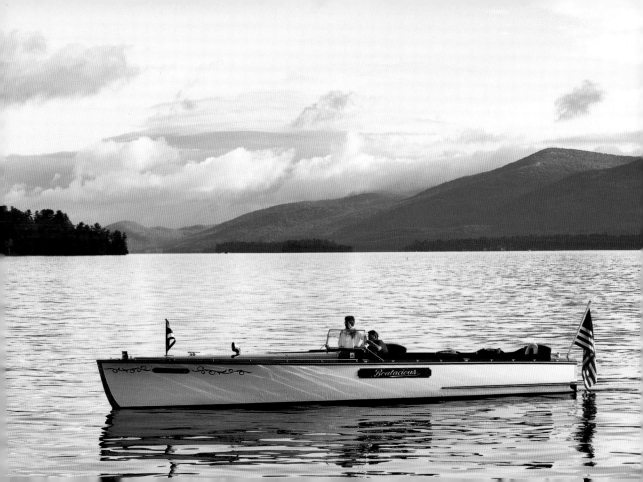

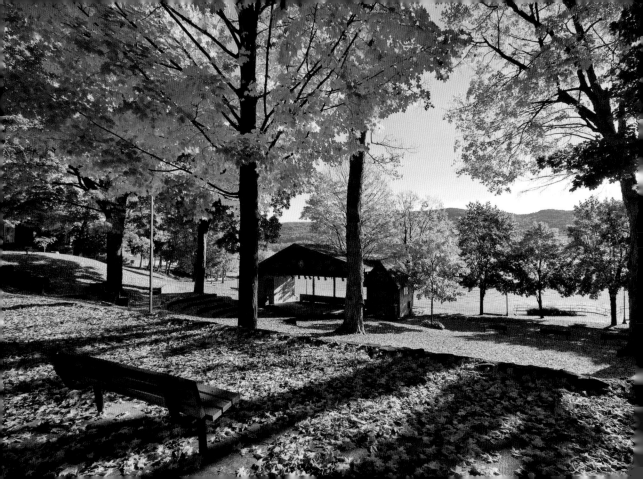

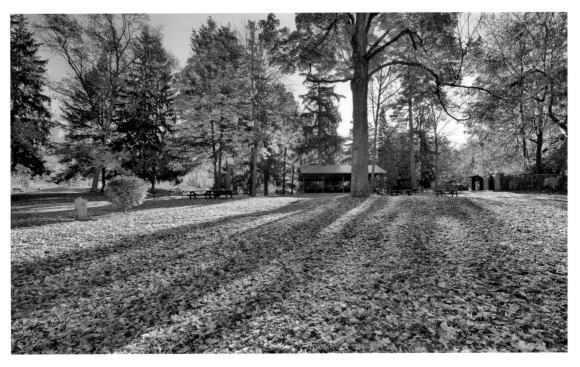

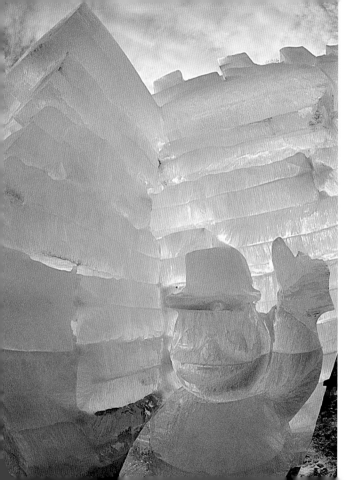

left *Ice castle at the Winter Carnival*
opposite *New Year's Day Polar Bear swim at Shepard Park*
following page *Outhouse races at the Winter Carnival*

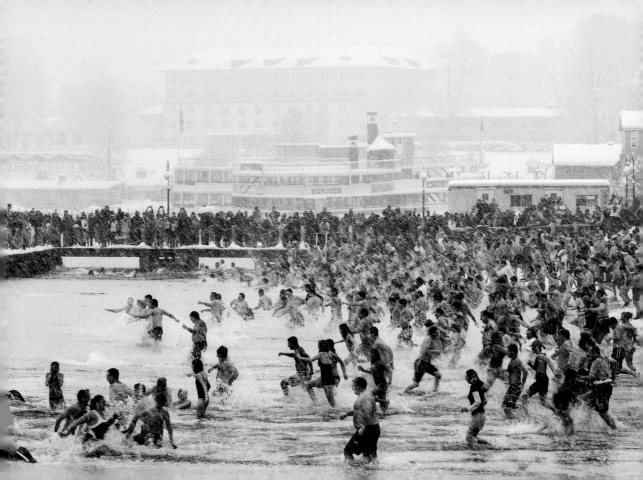

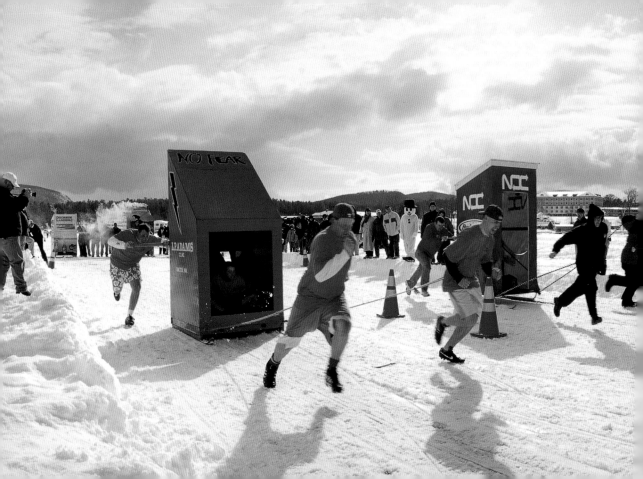

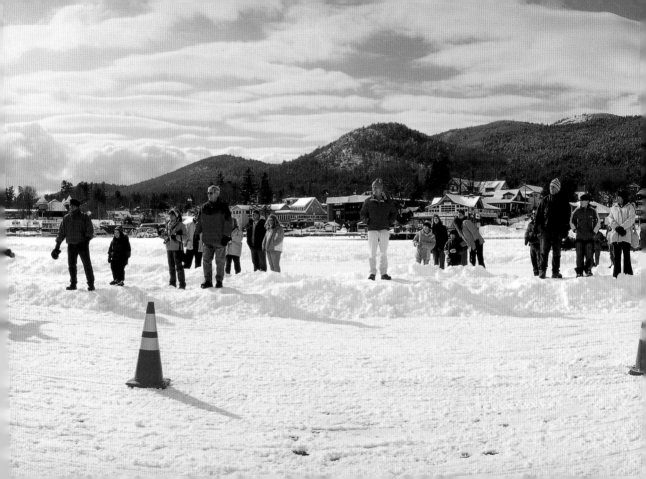

left *Lake George Historical Society*
opposite *December snowstorm in Lake George Village*

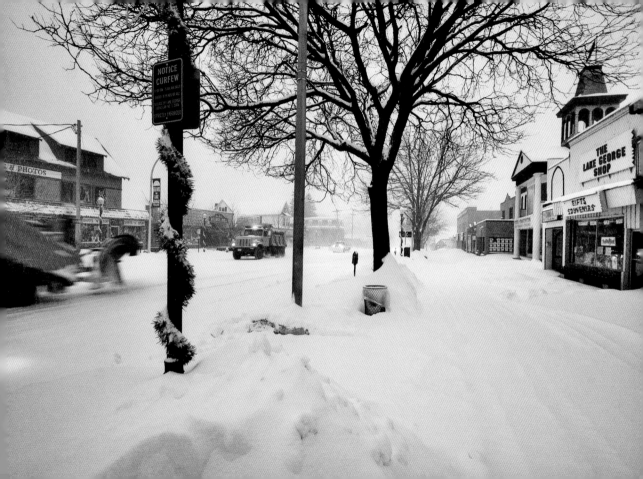

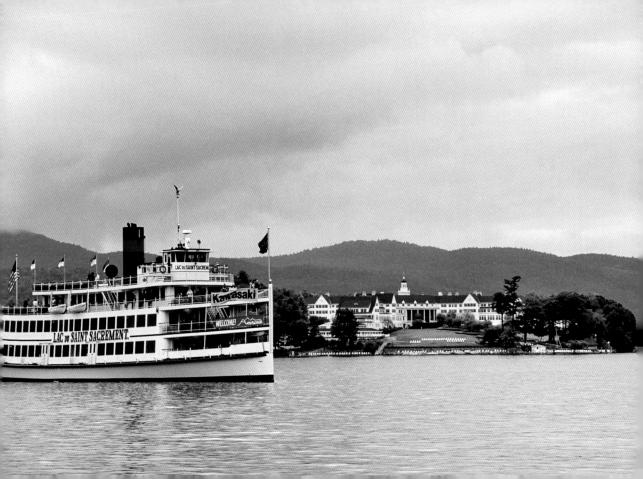

Southern Lake George

Assembly Point • Bolton Landing
Diamond Point • Cleverdale • Pilot Knob

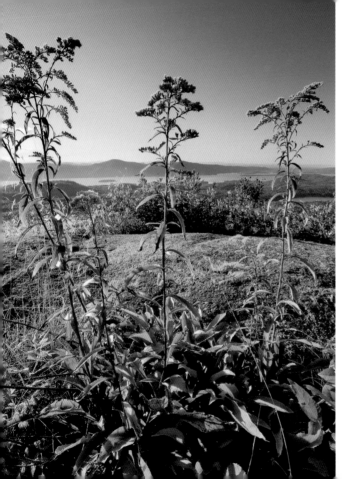

left *Goldenrod on Cat Mountain*
opposite *Pink lady slippers in Northwest Bay*
previous page *Tour boat* Lac du St. Sacrement
near The Sagamore

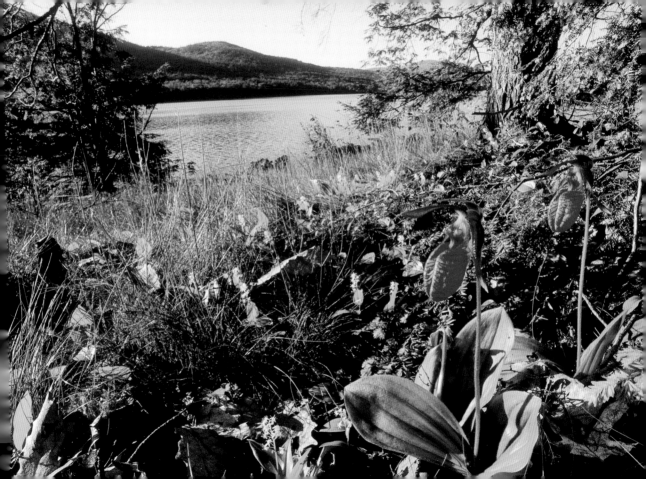

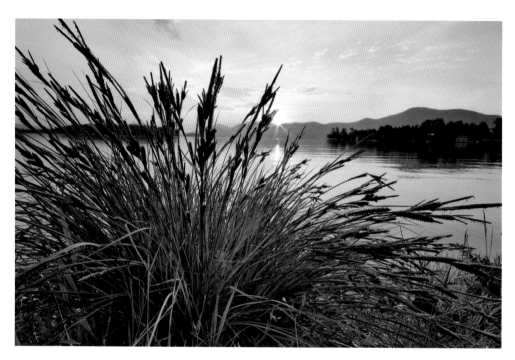

above *Sunrise light over Basin Bay*
opposite *Dawn from Diamond Point*
following page *View from Stewart's Ledge*

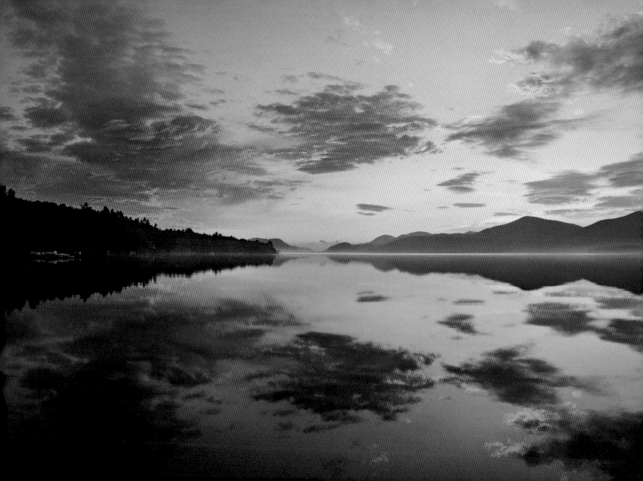

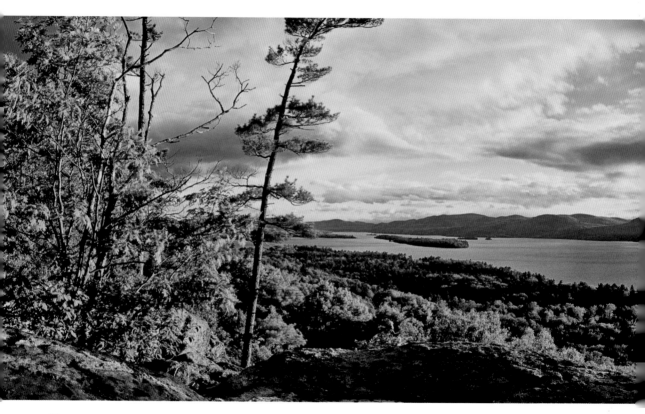

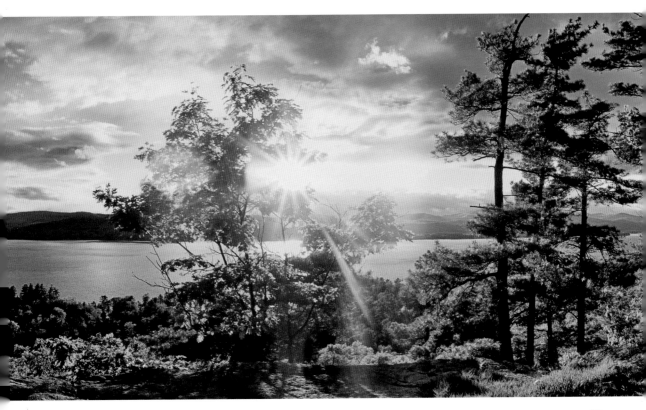

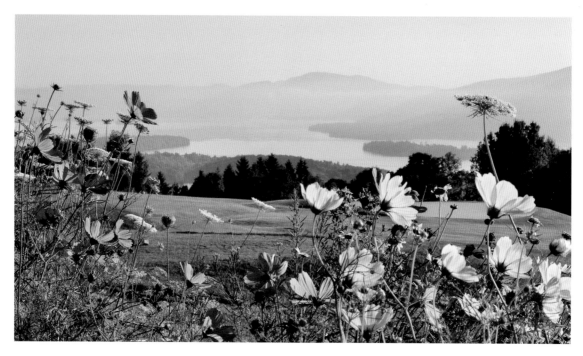

above *Top of the World golf course on French Mountain*
opposite *The Sagamore, Bolton Landing*
following page *The Sagamore*

58

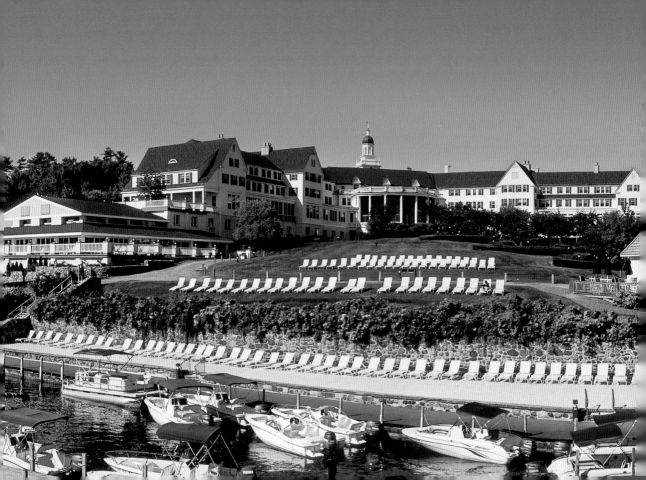

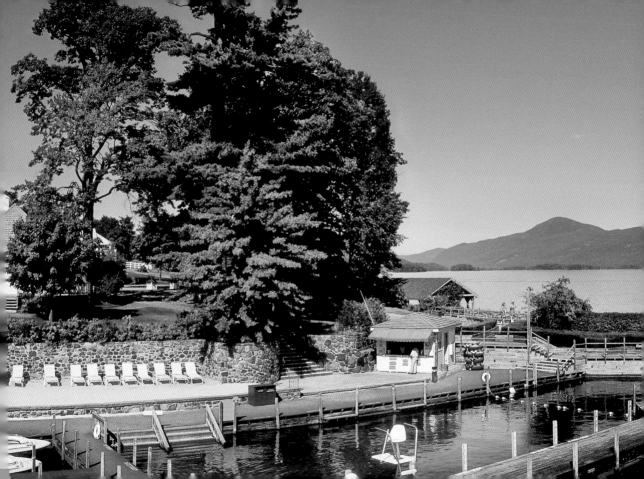

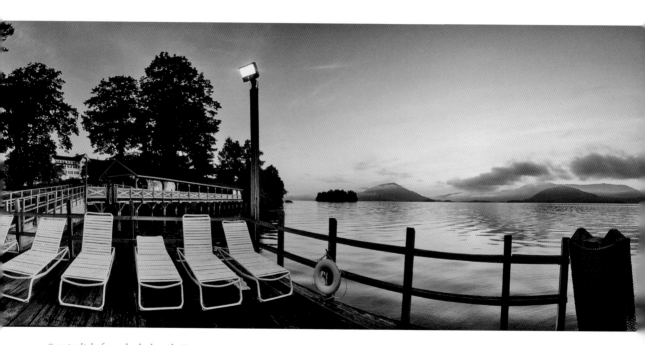

Sunrise light from the dock at the Sagamore

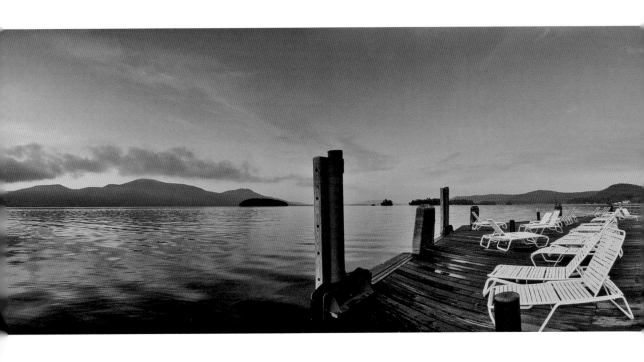

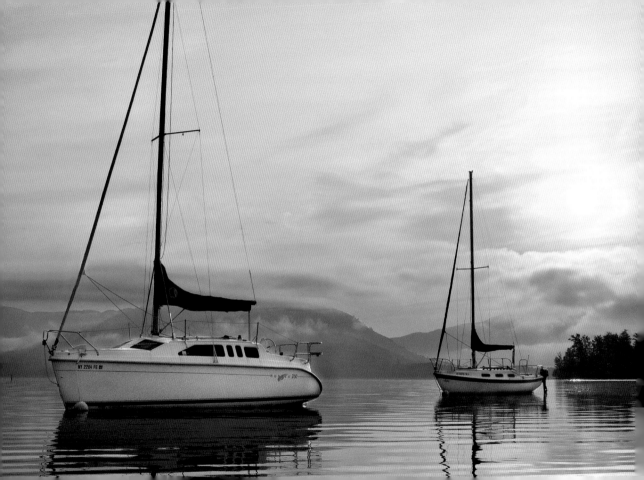

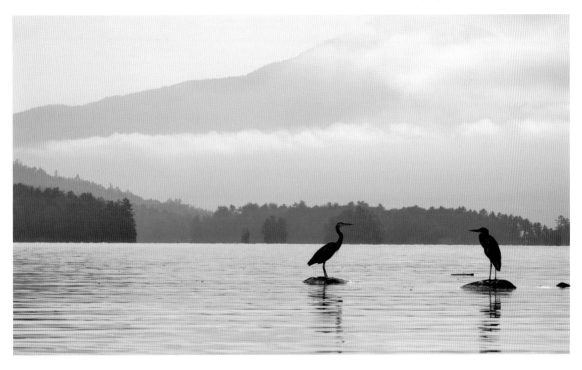

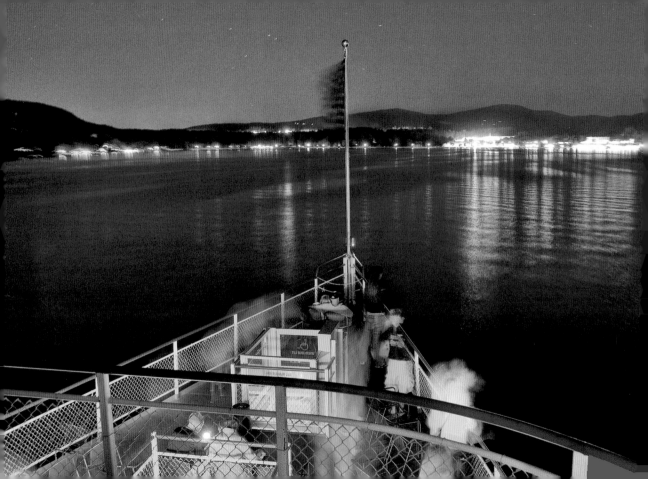

above Sunrise over the Tongue Mountain Range
opposite View down the lake from the deck of the Lac du Saint Sacrament
following page Looking up Lake George toward the Tongue Mountain Range, the Narrows, and Black Mountain

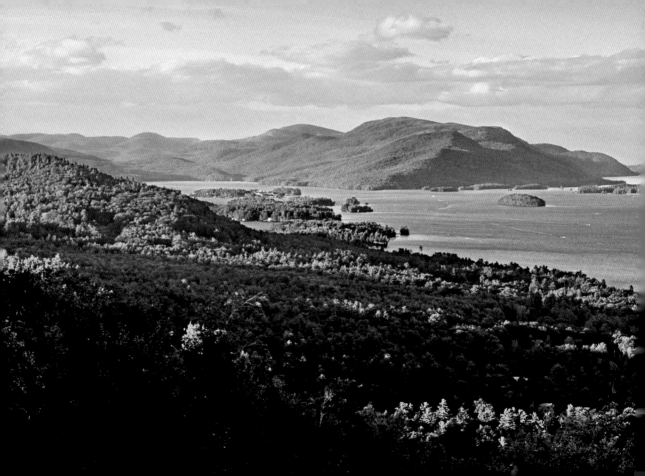

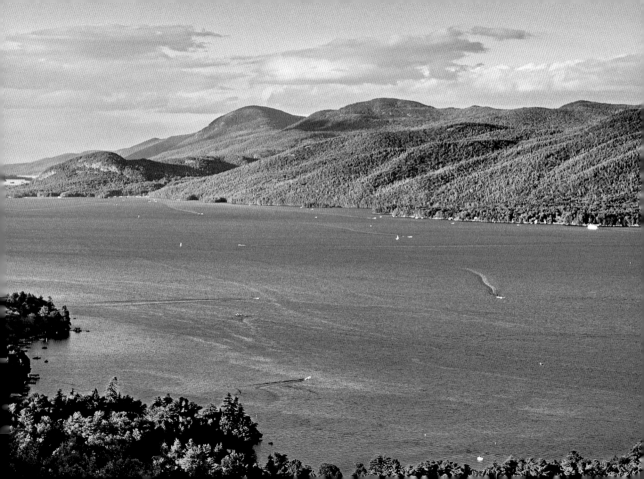

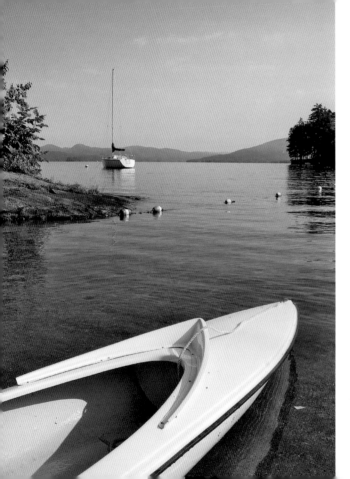

left *Rowing shell at Camp Chingachgook, Pilot Knob*
opposite *Sailboats at Camp Chingachgook*
following page *Sunrise over Assembly Point*

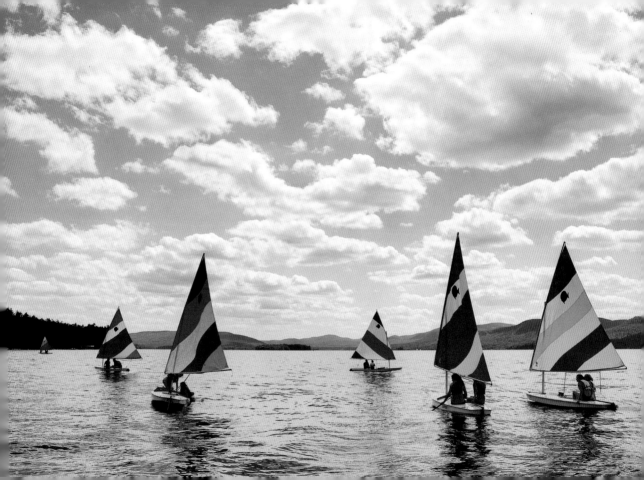

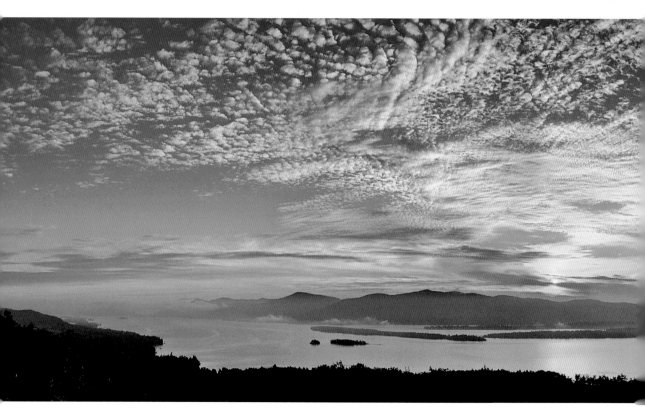

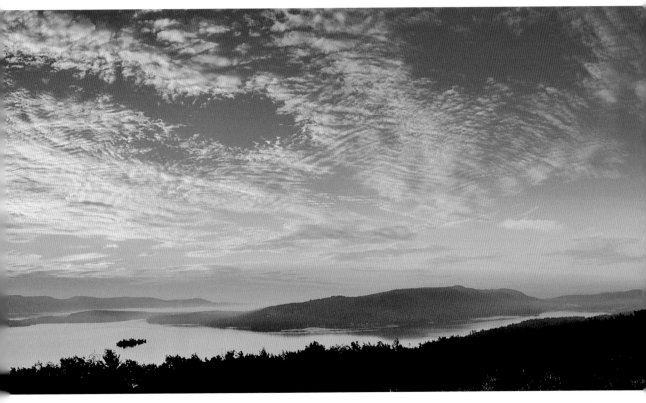

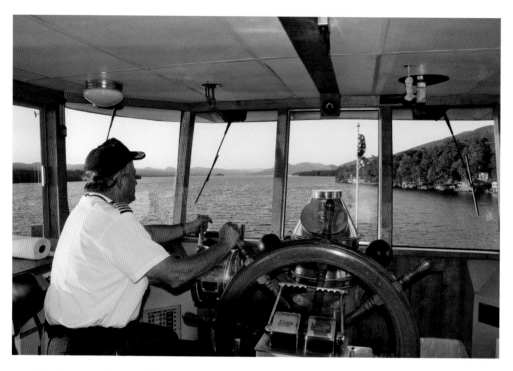

above *View from the pilot house of the* Lac du Saint Sacrament
opposite *Cliff-jumping at the Calf Pen*

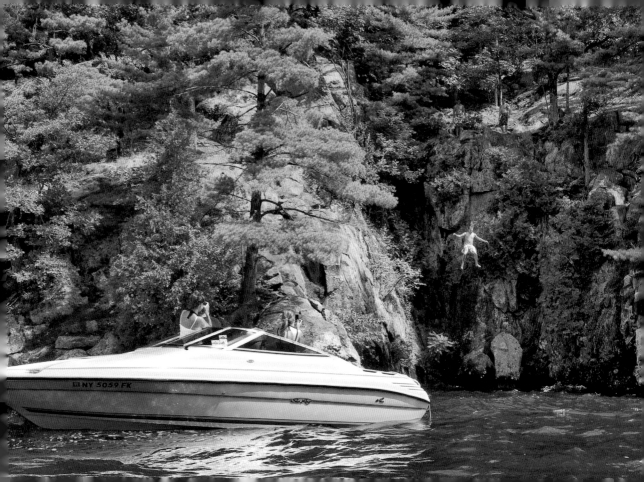

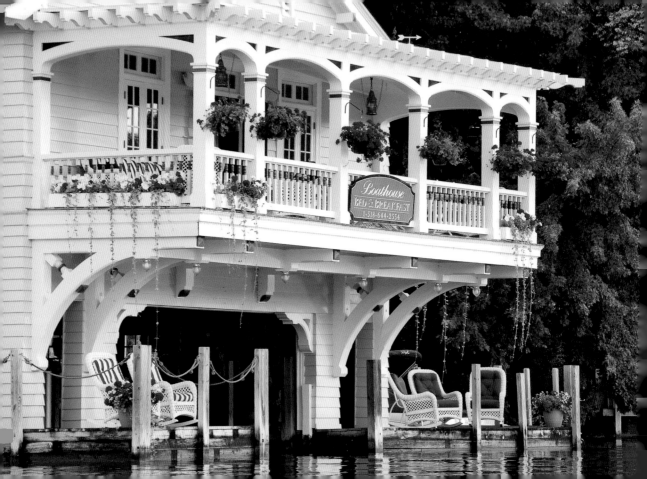

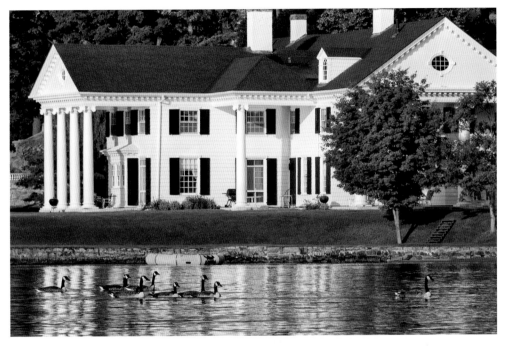

above The Bixby estate on Mohican Point
opposite Boathouse Bed & Breakfast next to the Sagamore Road bridge, Bolton Landing
following page Sunrise over Lake George from an overlook above Bolton Landing

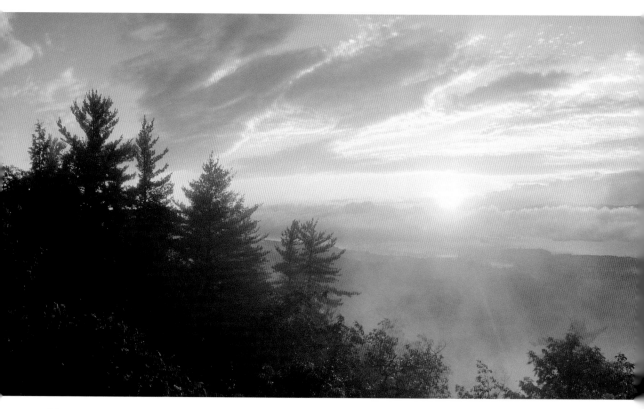

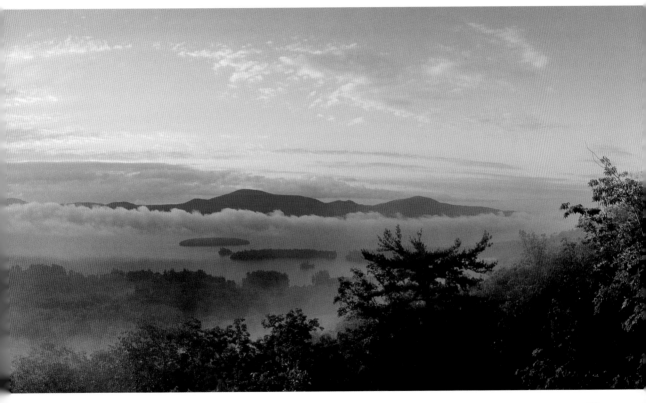

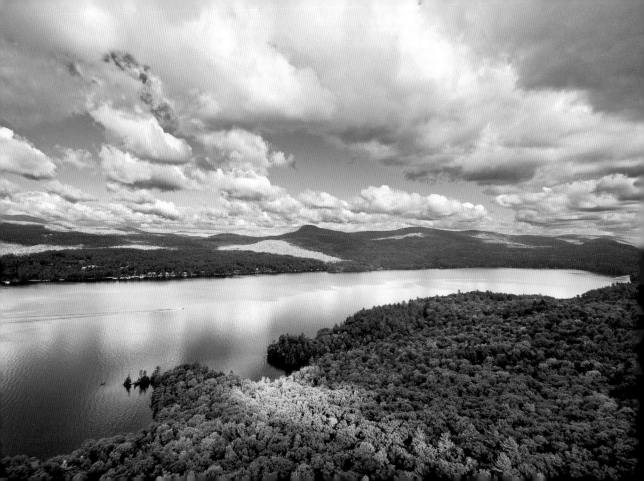

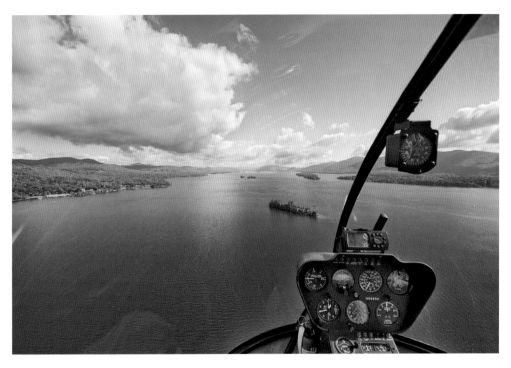

above *View north over Diamond Island from a helicopter*
opposite *Aerial view of Northwest Bay*

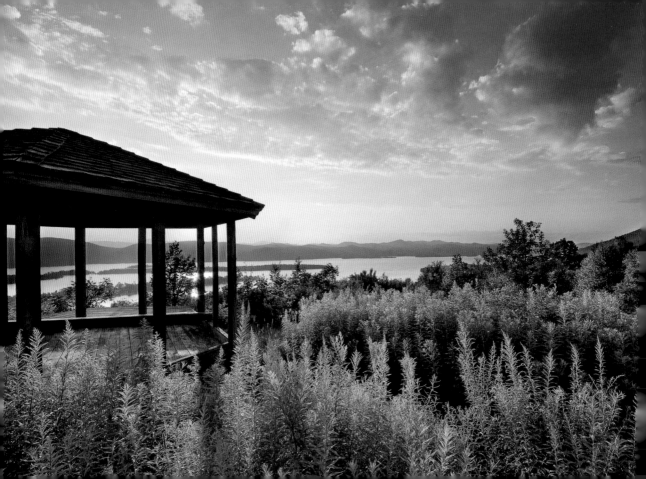

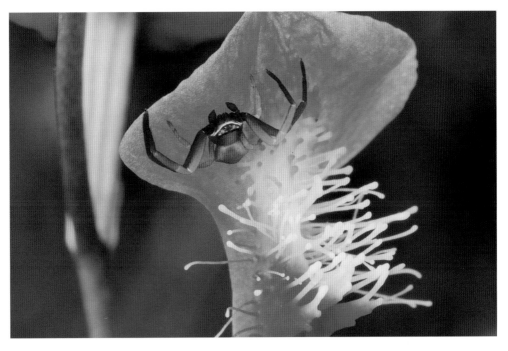

above *Grass pink and crab spider in a Harris Bay bog*
opposite *View of the Pilot Knob Ridge Preserve gazebo and Long Island*
following page *Full moon rising over the Narrows, Bolton Landing, and the Sagamore*

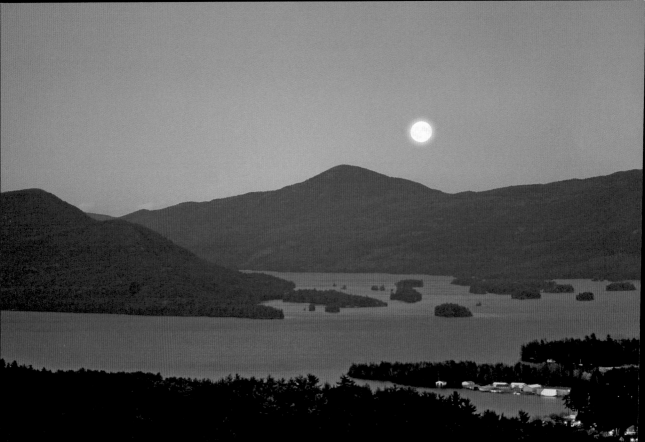

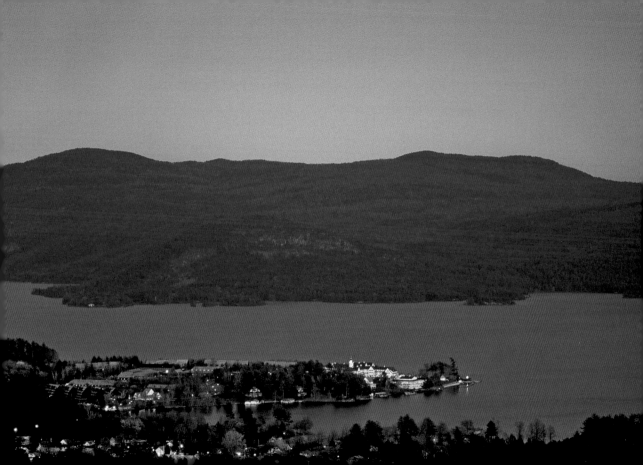

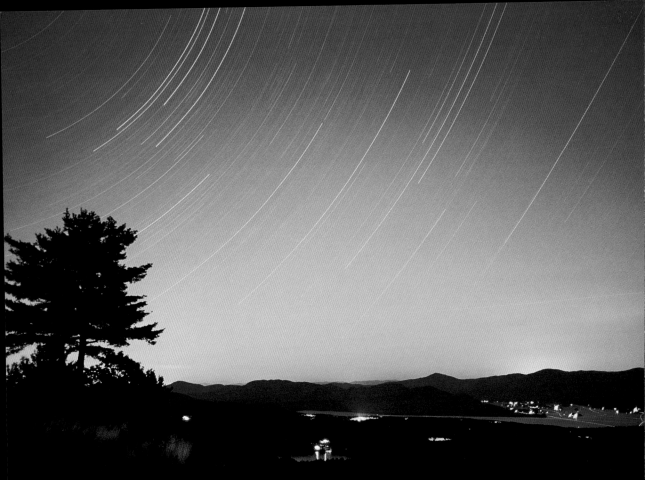

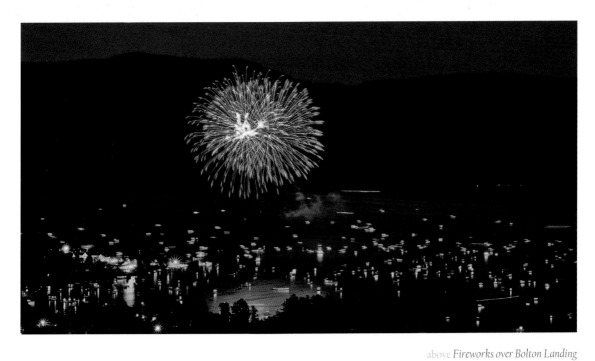

above *Fireworks over Bolton Landing*
opposite *Star tracks at dusk from Cat Mountain*
following page *Southern Lake George seen from Cat Mountain, including the Tongue Mountain Range, Black Mountain, and Sleeping Beauty on the left; Buck Mountain and Pilot Knob in the center; and Prospect Mountain to the right*

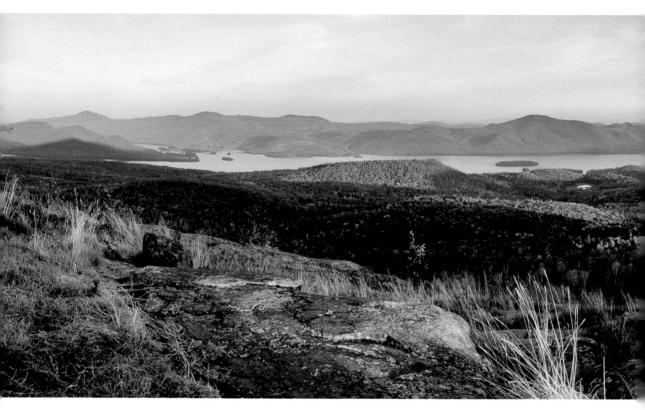

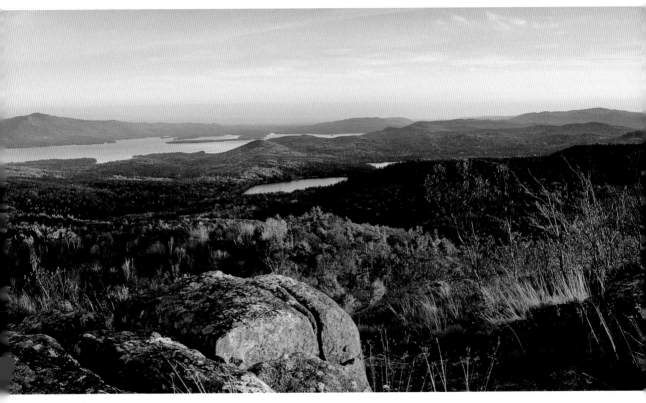

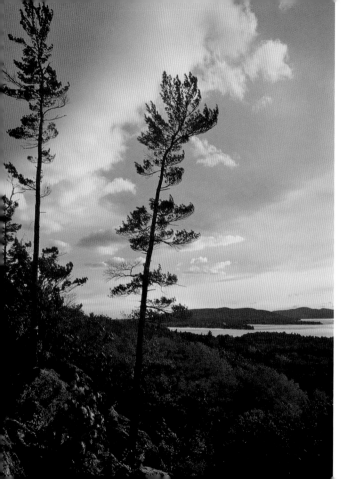

left View from Stewart's Ledge, looking toward
Lake George village
opposite Birch and maples on a farm along Route 9L
following page The Narrows from the field above Up Yonda
Farm, Bolton Landing

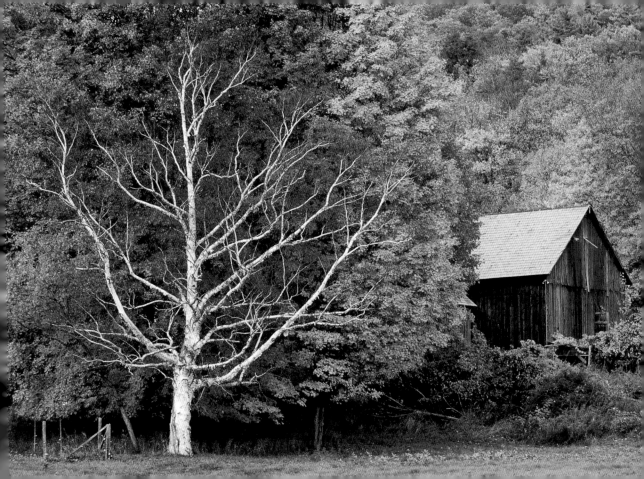

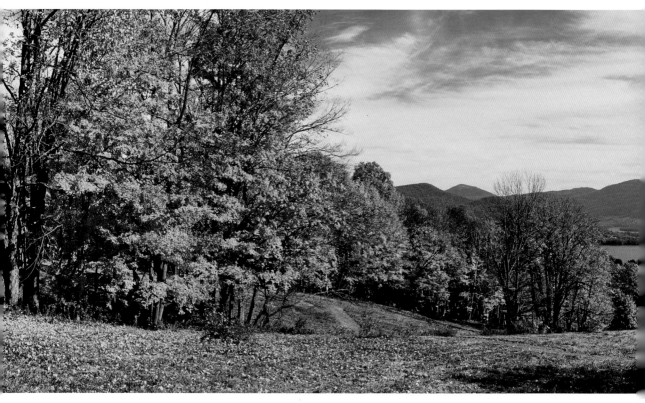

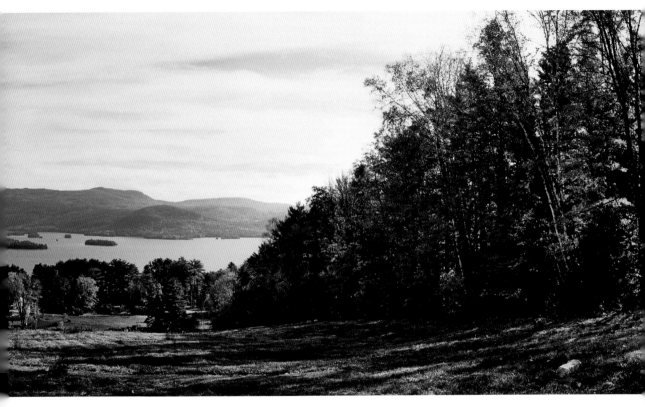

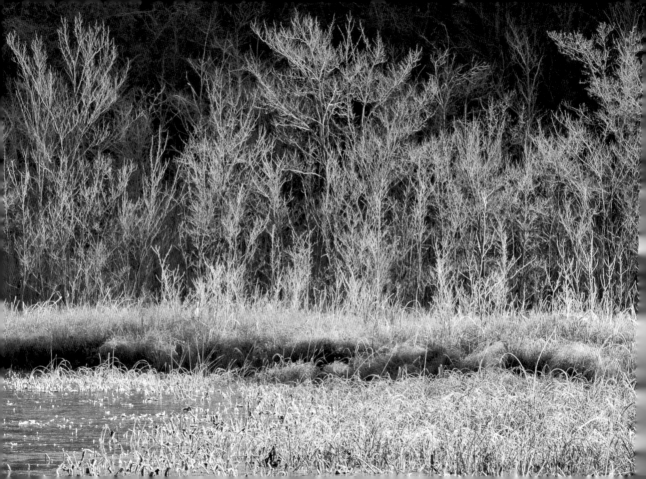

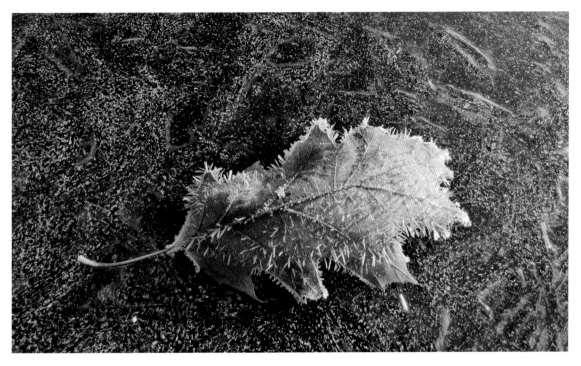

above *A frost-covered leaf on Dunham Bay*
opposite *Frosty trees, grasses, and fresh ice on the bay*

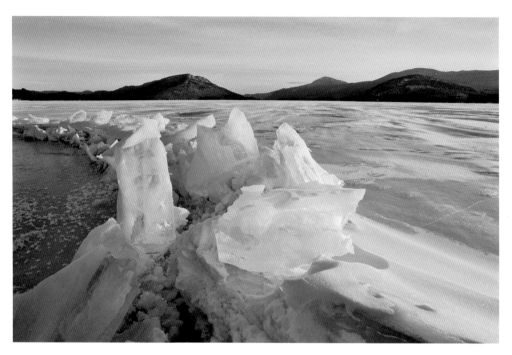

above *Ice pressure ridge just south of the Narrows*
opposite *Snow on the docks at the Algonquin, Bolton Landing*
following pages *Frozen, wind-blown ice along Shelving Rock Bay*

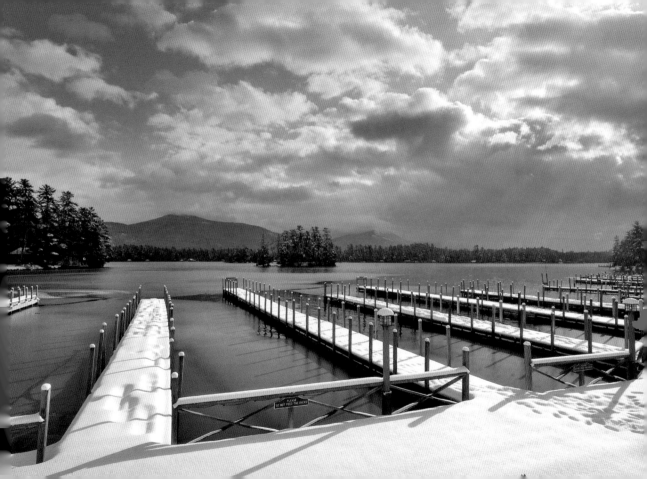

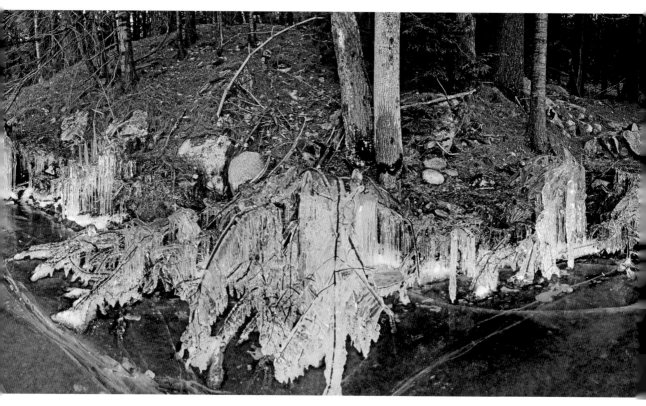

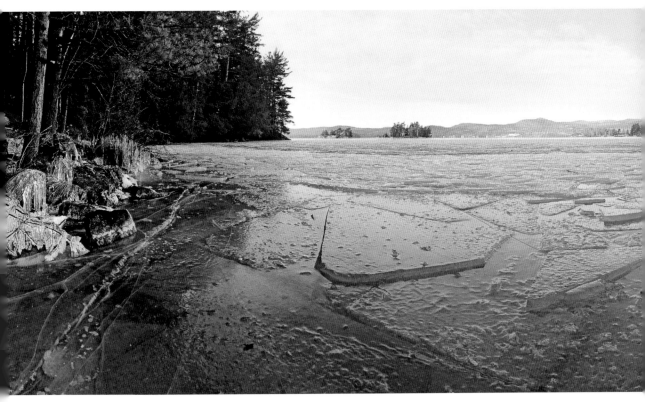

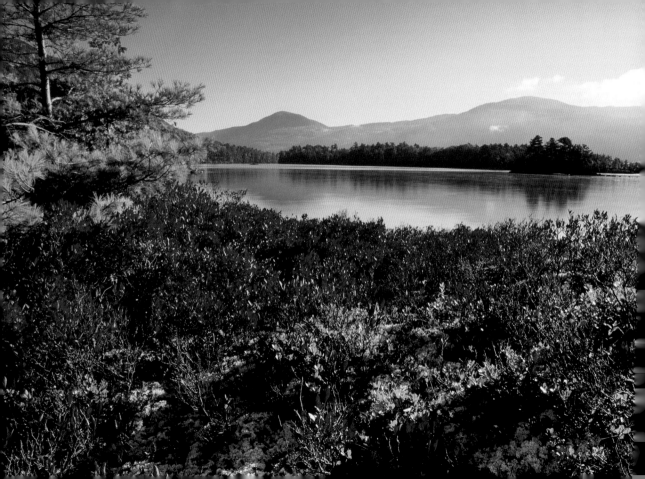

The Narrows and Lake George Wild Forest

Black Mountain · Buck Mountain · Jabe Pond
Sleeping Beauty · Tongue Mountain Range · Wardsboro

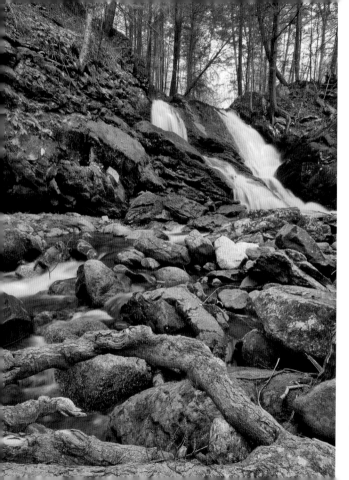

left *Waterfall along the outlet of Spectacle Ponds, Wardsboro*
opposite *Trillium along a tributary to Fly Brook*
previous page *Looking north to Black Mountain from Mingo Island*

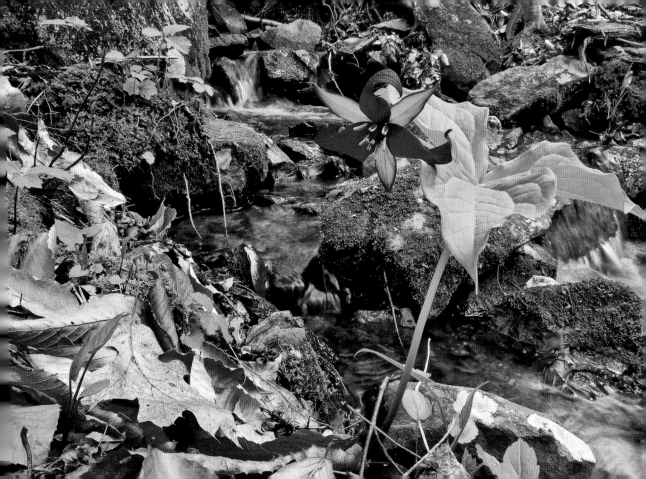

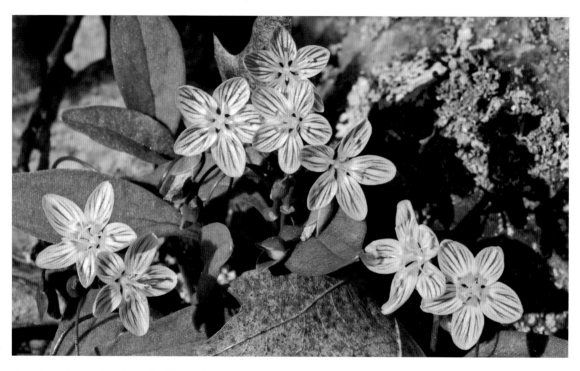

above *Spring beauty along the road to Jabe Pond*
opposite *Northwest Bay and the Narrows from Buck Mountain*

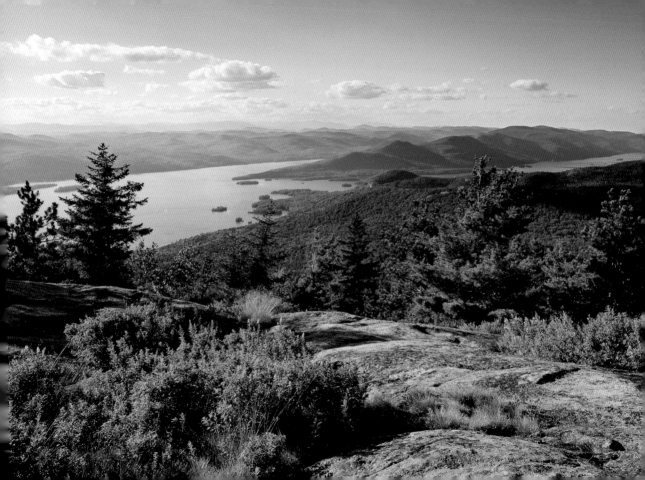

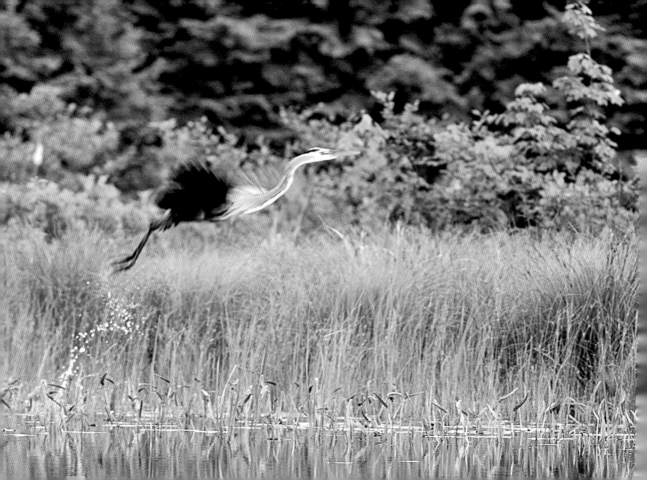

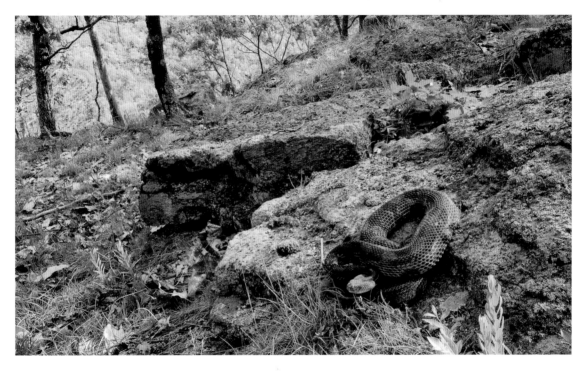

above *Eastern timber rattlesnake on rock outcropping*
opposite *A blue heron takes flight in Northwest Bay*

107

left Witch hopple and tree trunks along the Deer Leap trail
opposite Water lilies on Northwest Bay

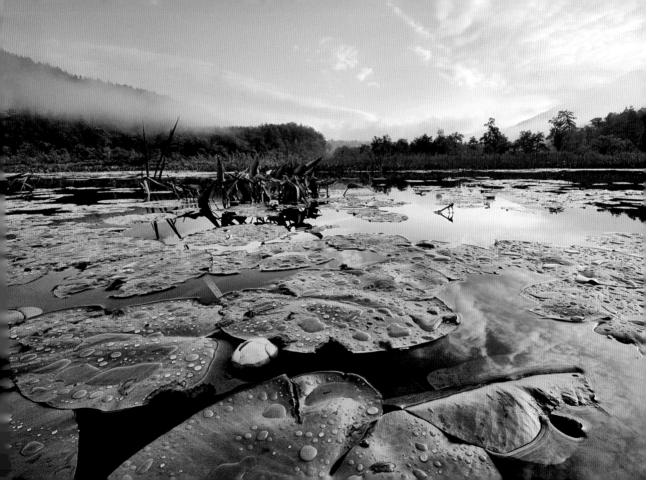

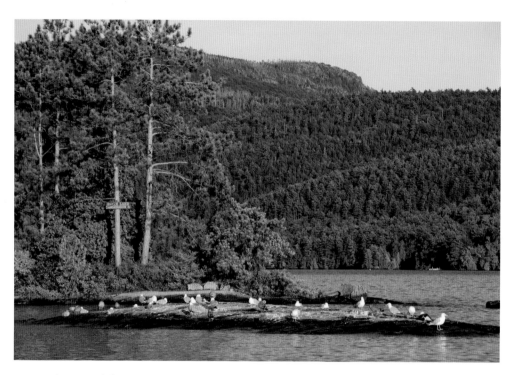

above Looking toward Sleeping Beauty Mountain
opposite View from the cliffs on Sleeping Beauty

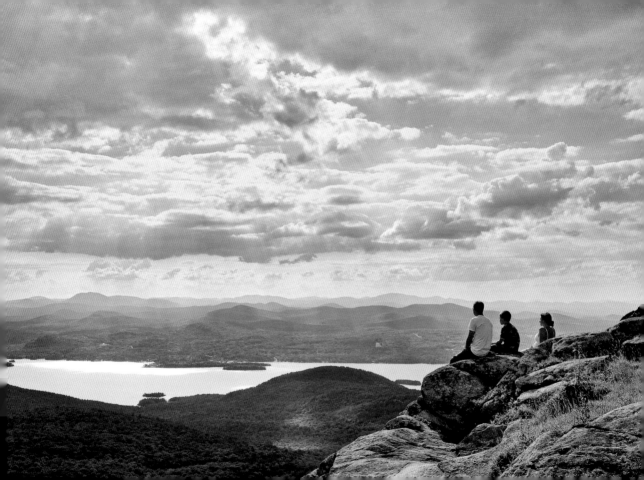

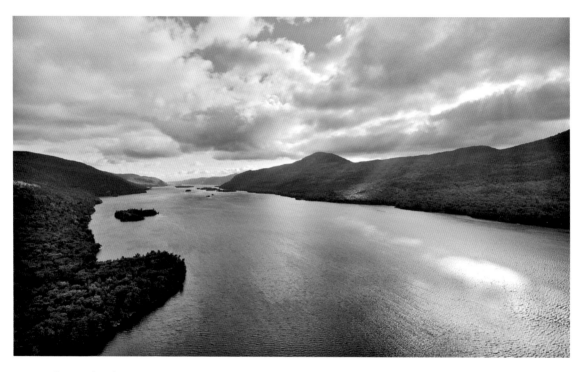

above *Looking north in the Narrows*
opposite *The Narrows and Deer Leap*

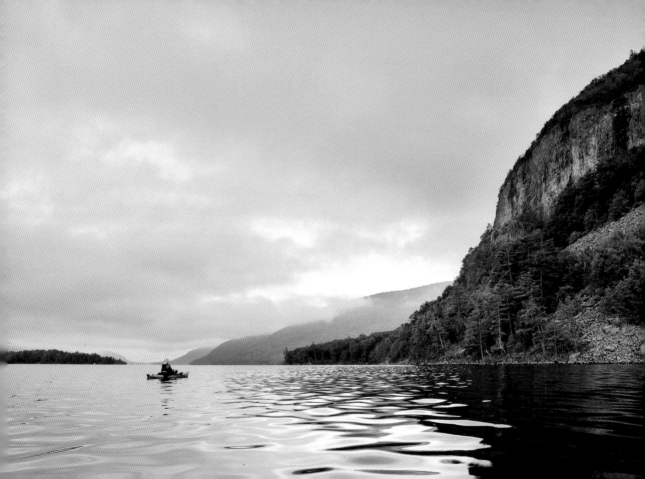

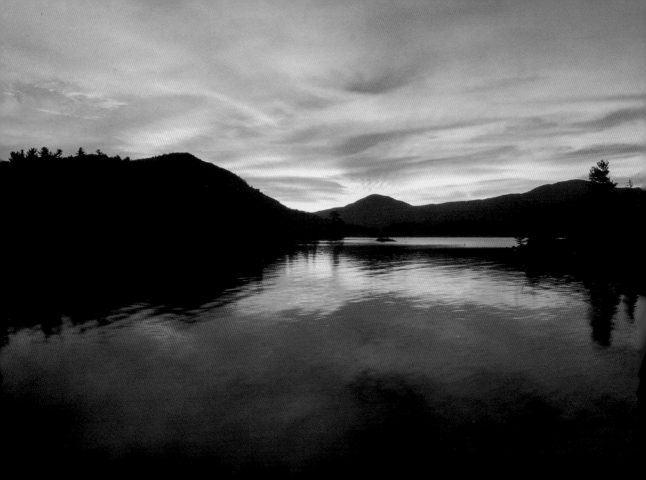

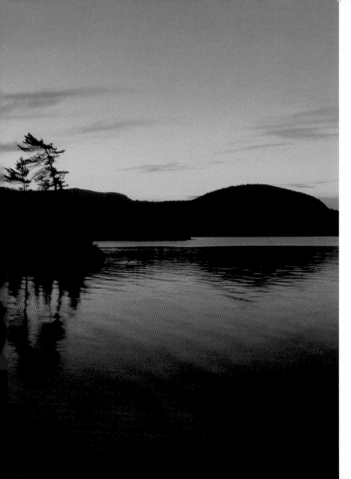

The southern Narrows at sunrise

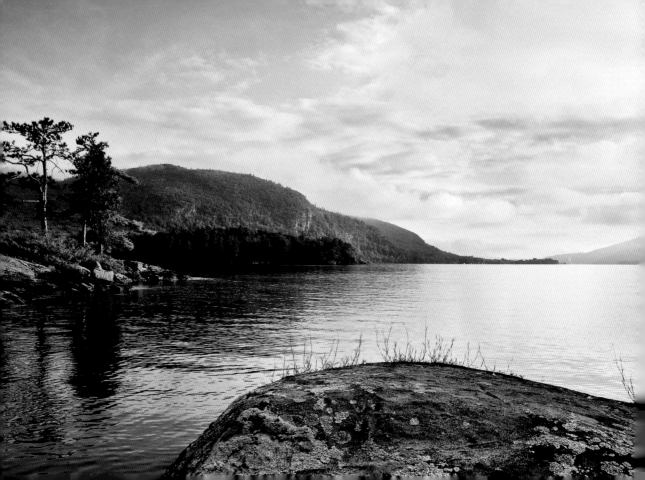

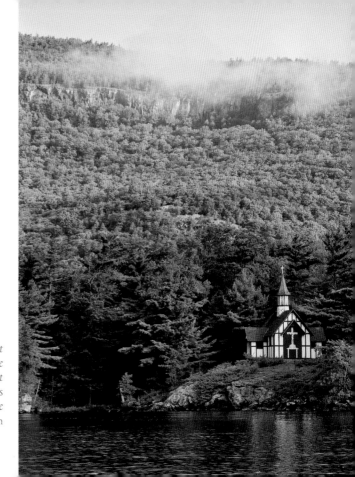

right *Cliffs on Brown Mountain behind the Paulist
Fathers chapel, St. Mary's on the Lake*
opposite *Vicar Island, Deer Leap, and Sabbath Day Point
from the north end of the Harbor Islands*
following page *Looking north into the Narrows to the Tongue
Mountain Range and Black Mountain from the* Mohican

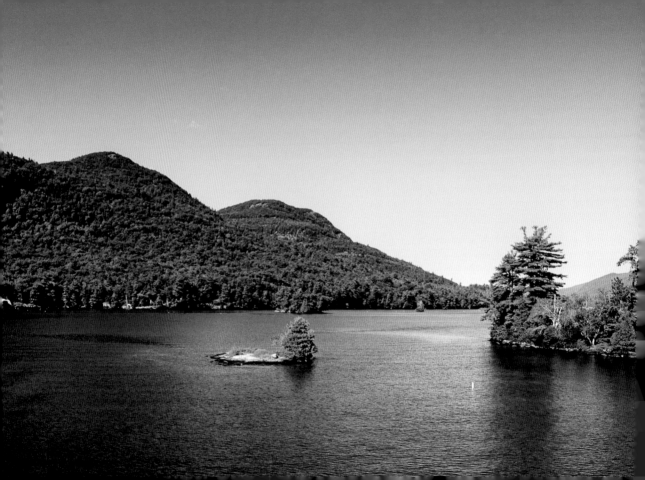

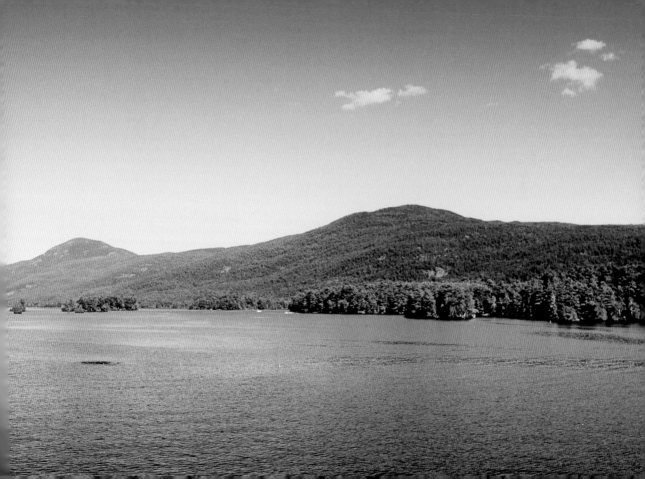

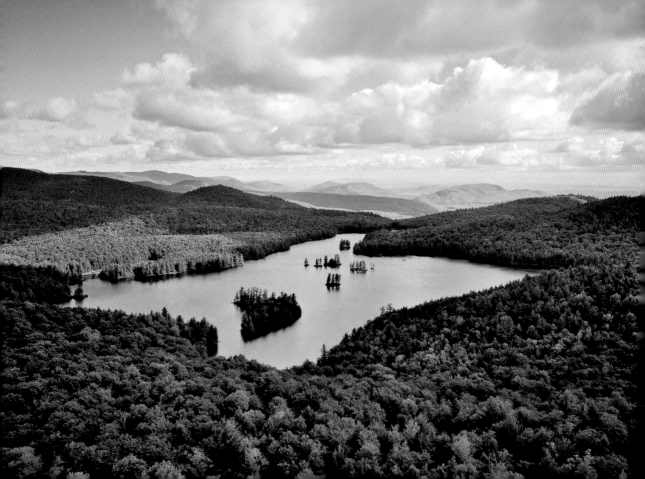

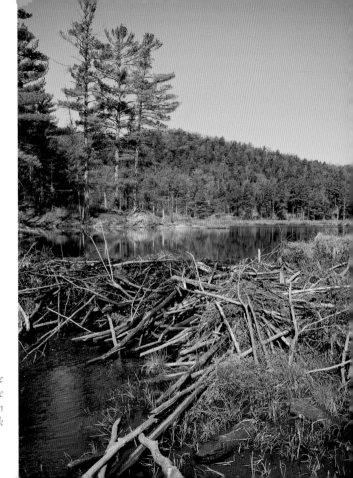

right Beaver dam, Ronning Preserve
opposite Aerial view of Jabe Pond and northern Lake George
following page Turtle Island and Shelving Rock Mountain
from a shoulder of First Peak

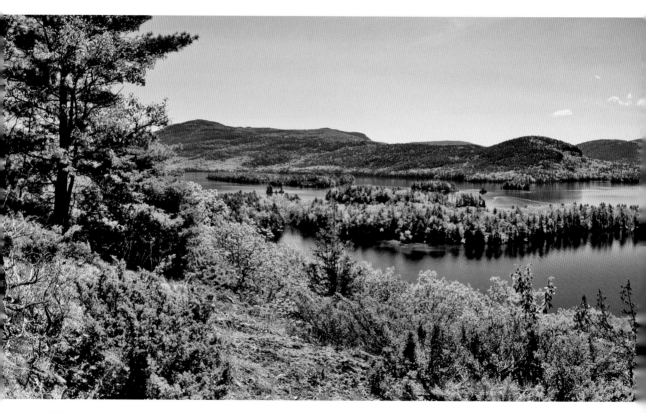

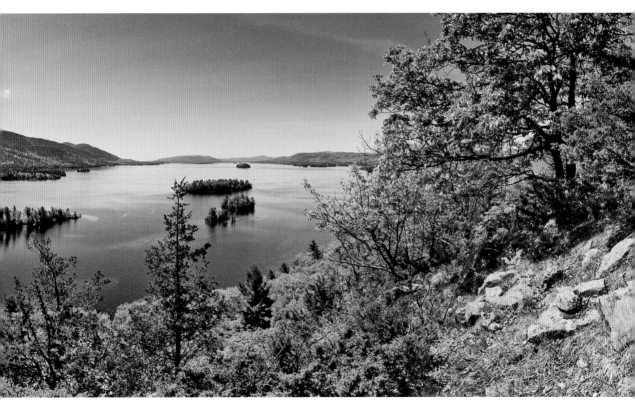

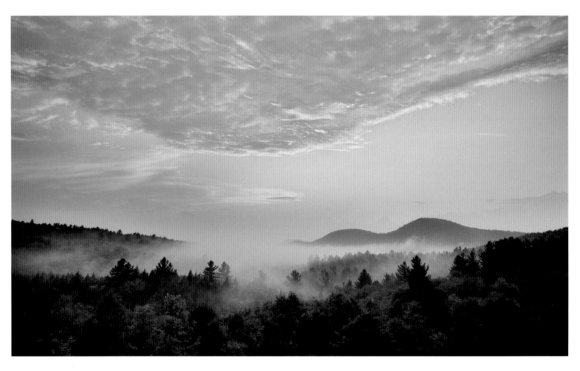

above Sunset light from the Route 8 pull-off below North Pond
opposite Sunrise light over the Mother Bunch and Harbor Islands from the summit of Black Mountain

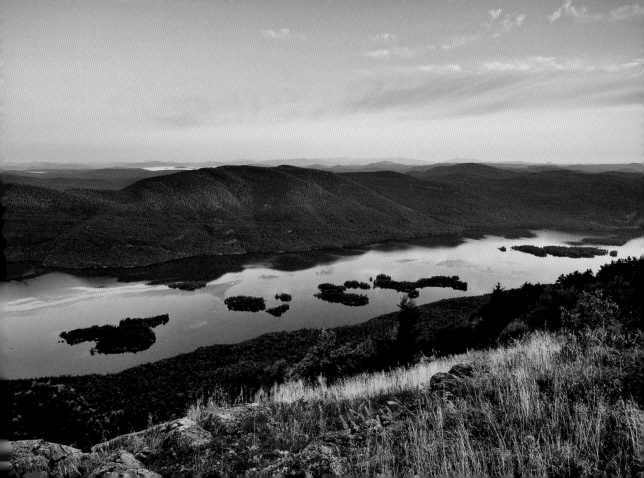

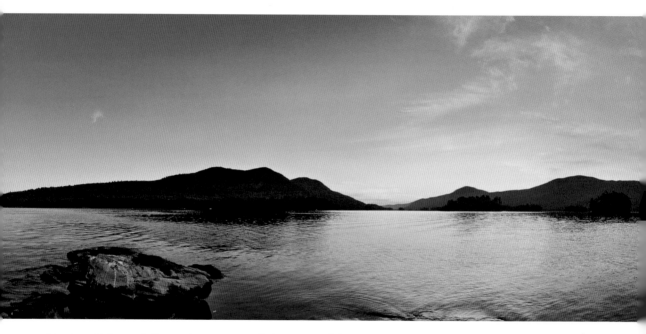

Morning twilight over the Tongue Mountain Range, Black Mountain, Shelving Rock Mountain, and Buck Mountain

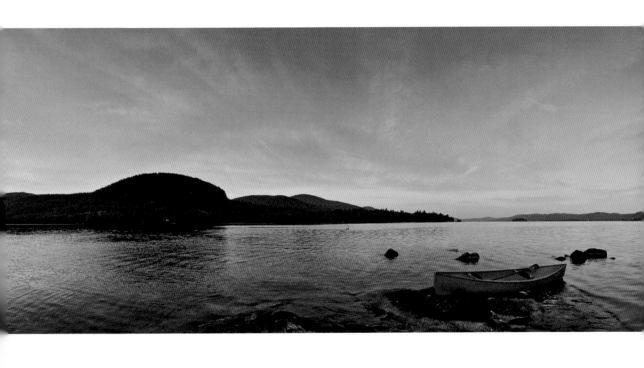

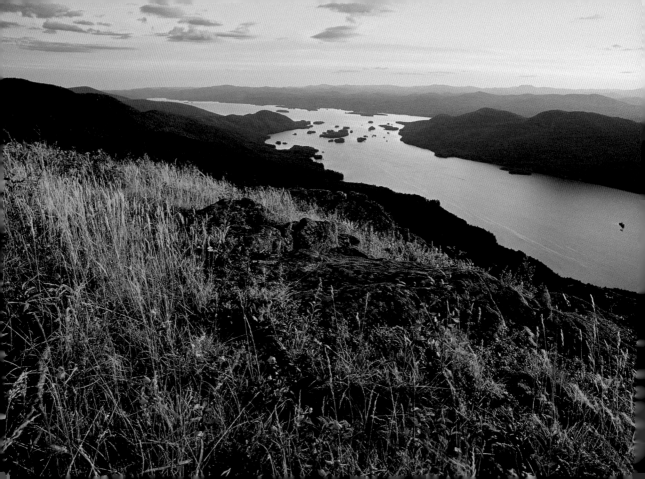

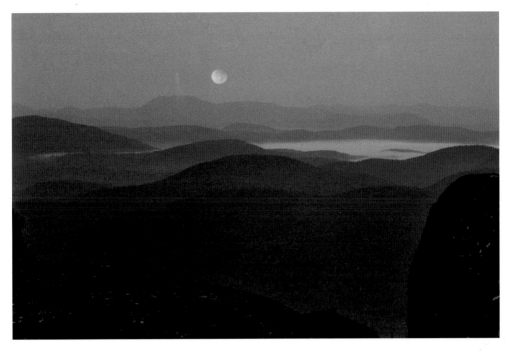

above *Moonset from Five Mile Mountain*
opposite *View south from Black Mountain at sunset*
following page *Cascade along Swede Pond Brook*

129

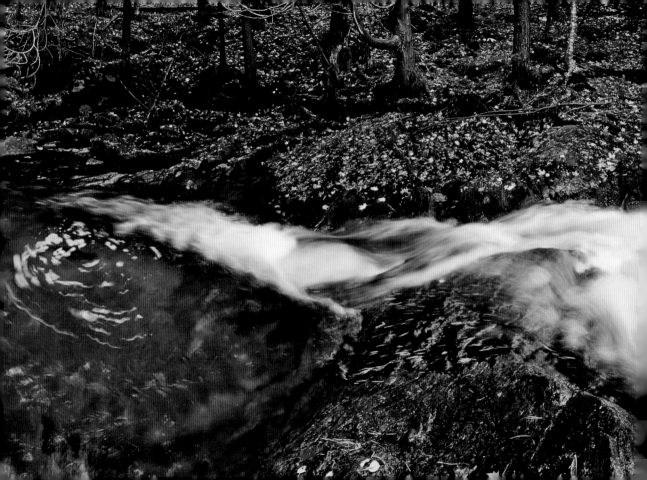

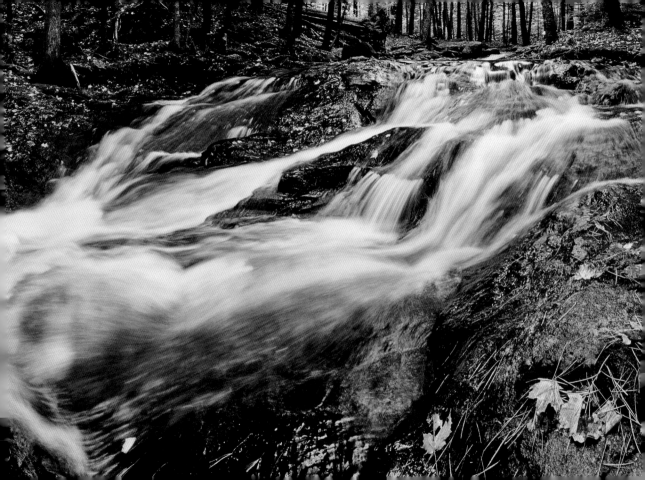

left Leaves along a stream near Shelving Rock Mountain
opposite Shelving Rock Falls
following page Beaver lodge on Spectacle Ponds

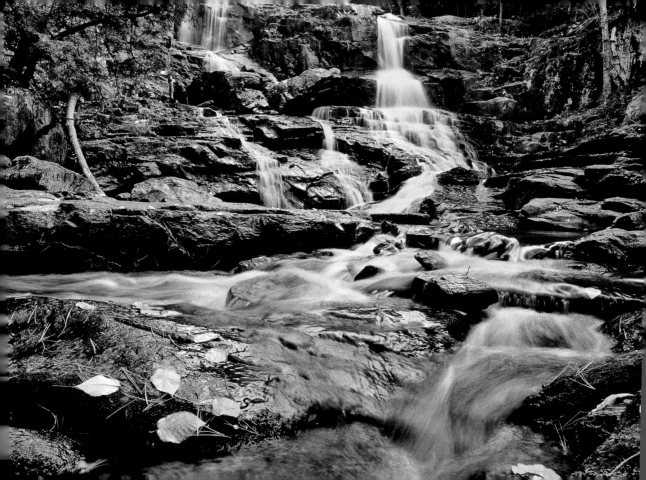

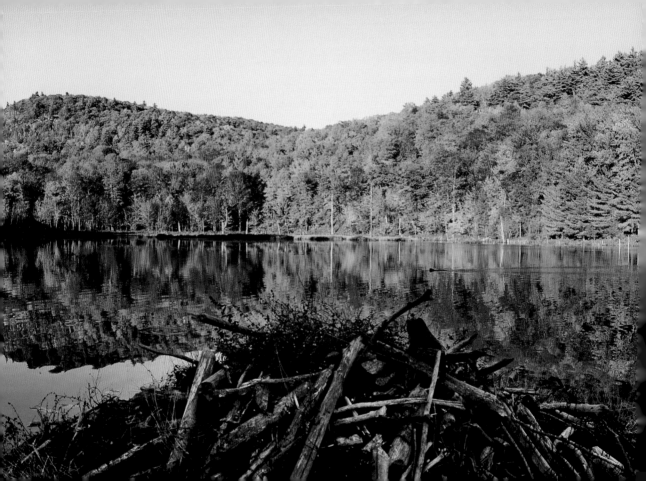

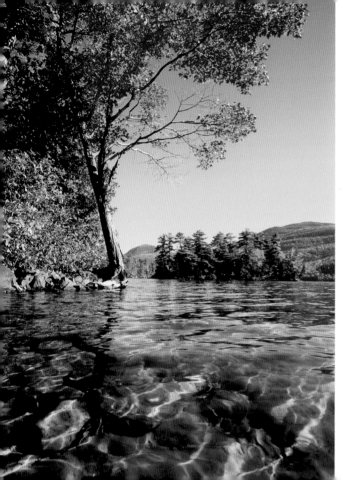

left *Looking north to Black Mountain from Phantom Island*
opposite *First ice around Mingo Island in the Narrows*

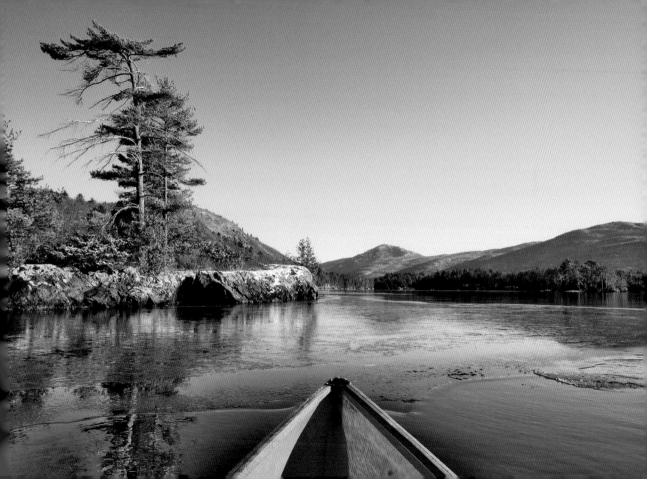

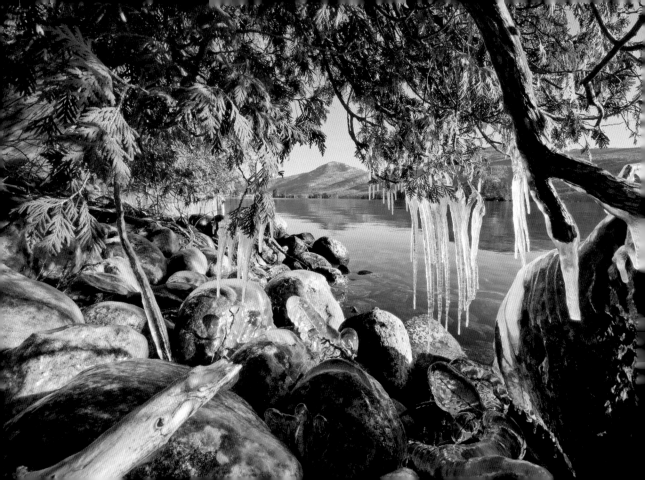

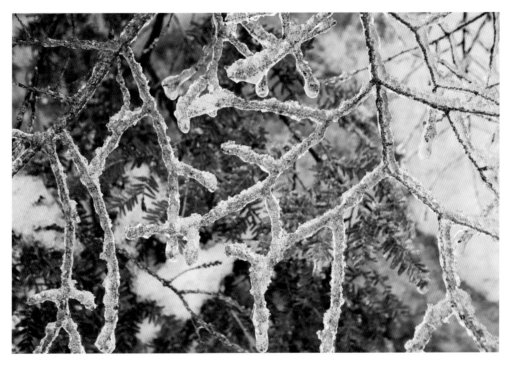

above *Ice on branches along the Clay Meadow trail to Tongue Mountain*
opposite *Looking north to Black Mountain from a small island at the south end of the Narrows*

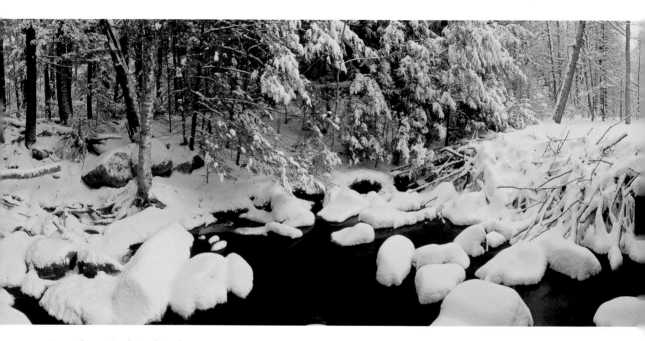

Beaver dam on Swede Pond Brook

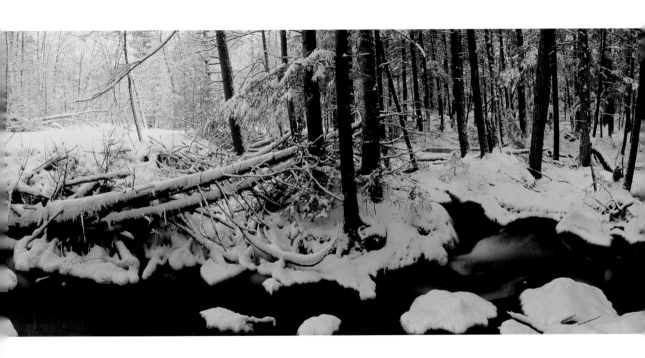

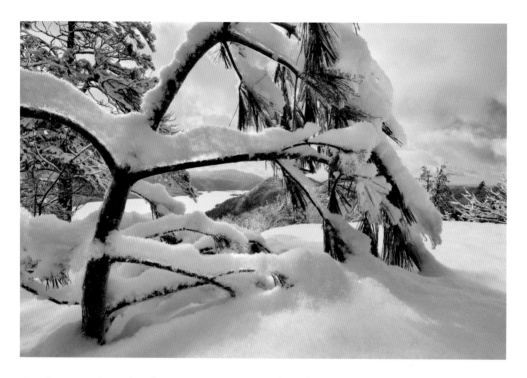

above Snow-covered trees along the Tongue Mountain Range trail on Fifth Peak
opposite Aerial view of the Narrows

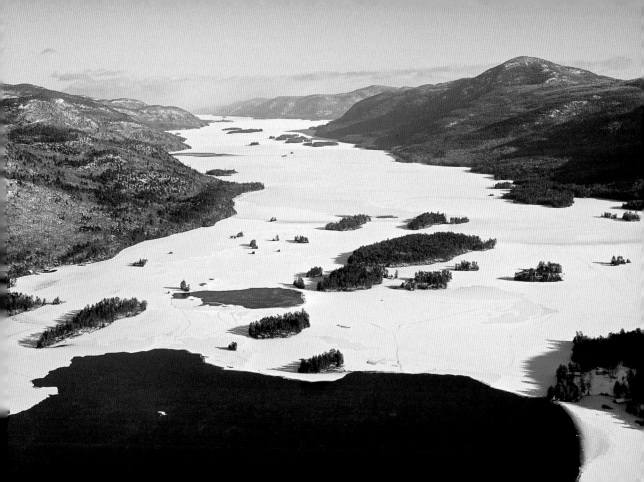

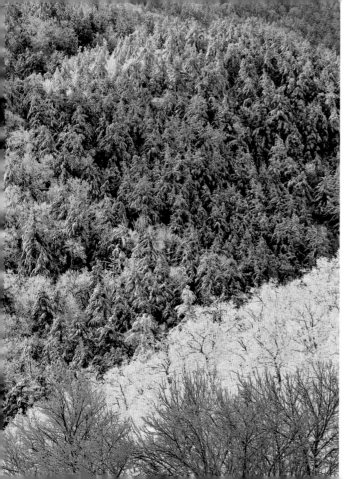

left *Ice and snow-covered trees from Fifth Peak*
opposite *The old schoolhouse along Wardsboro Road*

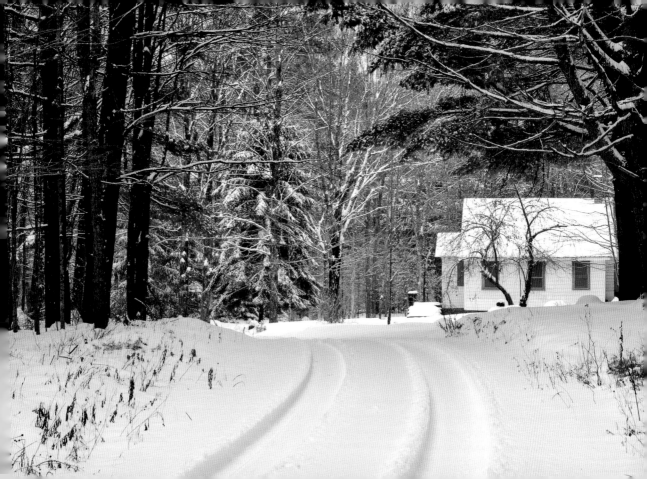

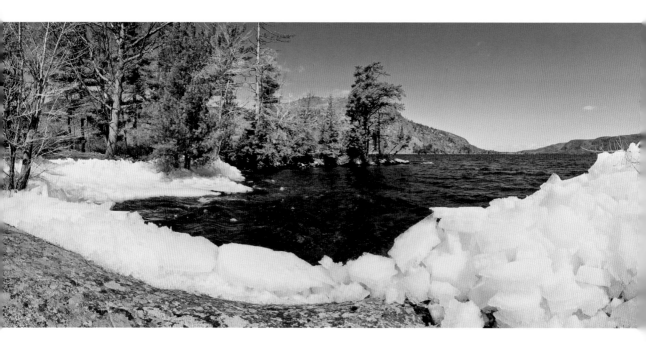

Wind-piled ice at spring thaw along the shore of Vicars Island

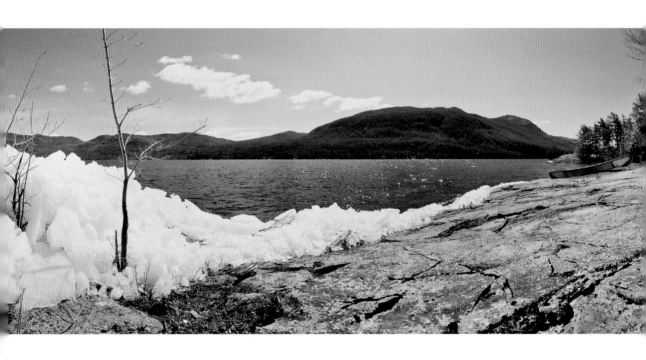

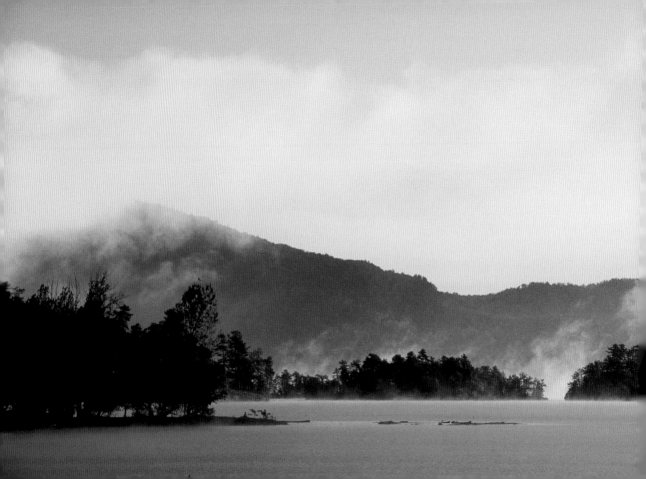

Northern Lake George

Glenburnie • Hague • Huletts Landing
Rogers Rock • Sabbath Day Point • Ticonderoga

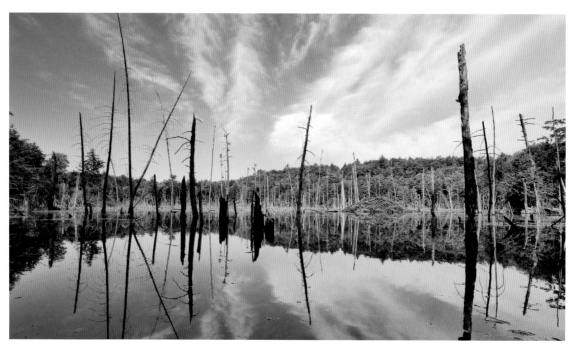

above *Beaver flow, Gull Bay Preserve*
opposite *Columbine south of Rogers Rock Campground*
previous page *Sunrise light from the Hague steamboat landing*

150

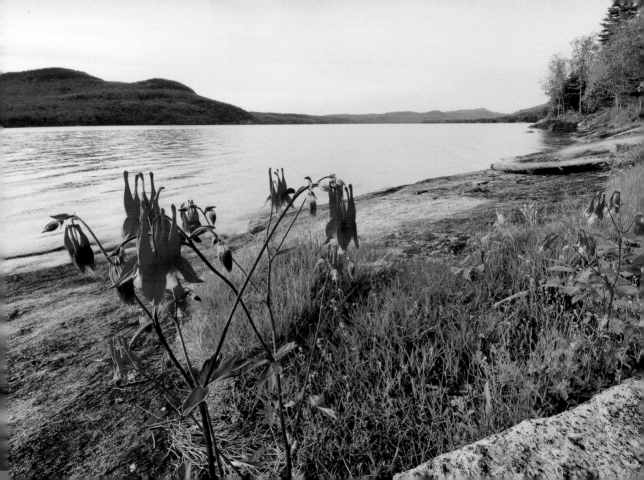

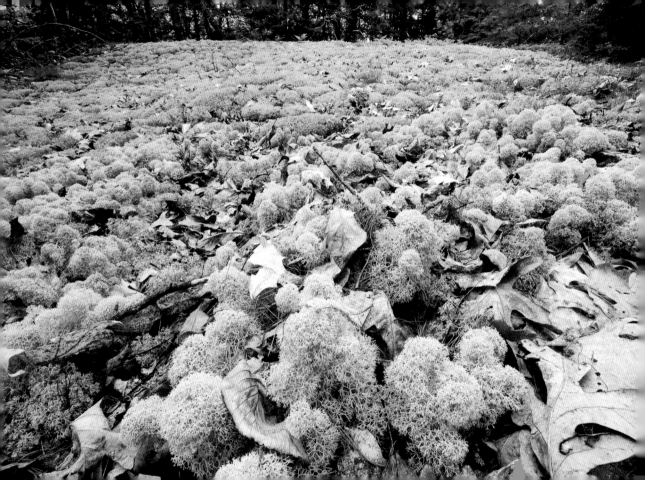

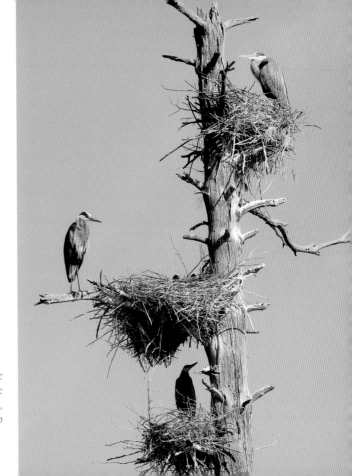

right *Blue herons in the rookery, Gull Bay Preserve*
opposite *Caribou moss, Gull Bay Preserve*
following page *View of Huletts Landing, Black Mountain, and the Narrows from Deer Leap*

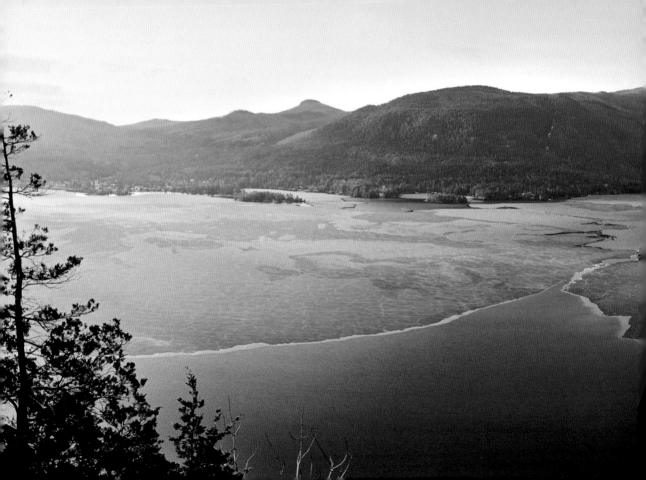

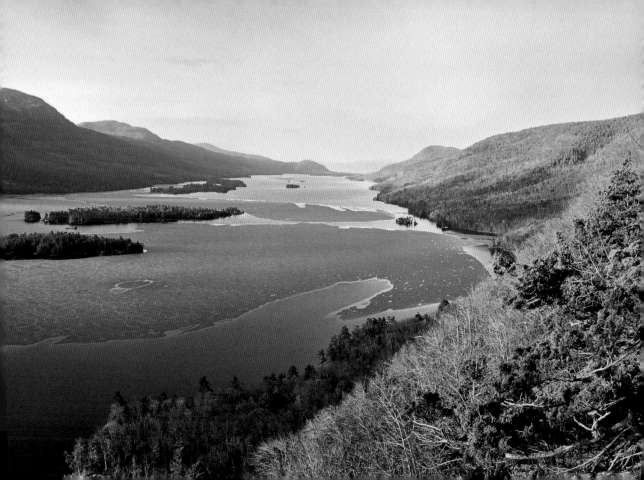

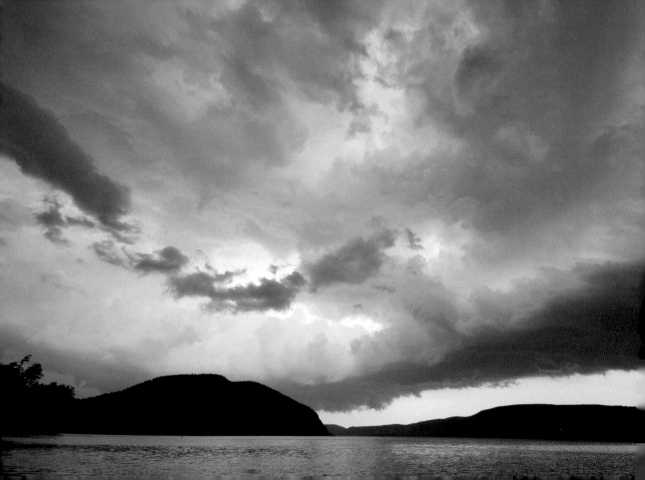

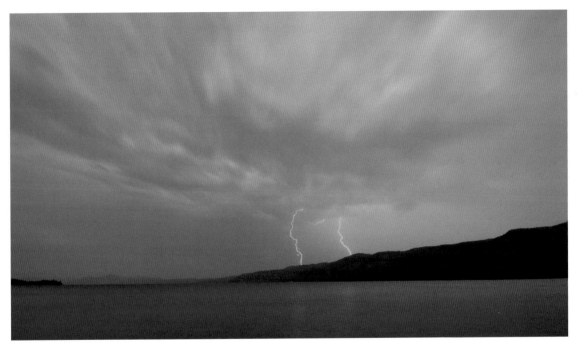

above *Lightning bolts, looking north from Silver Bay*
opposite *Storm clouds above Rogers Rock*
following page *Aerial view of Rogers Rock and Anthony's Nose*

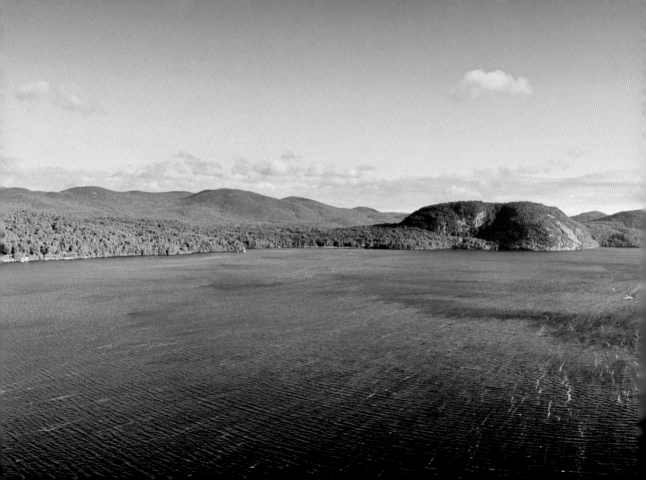

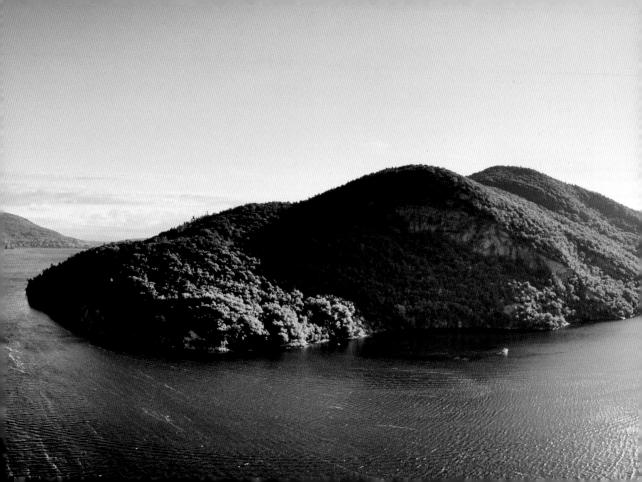

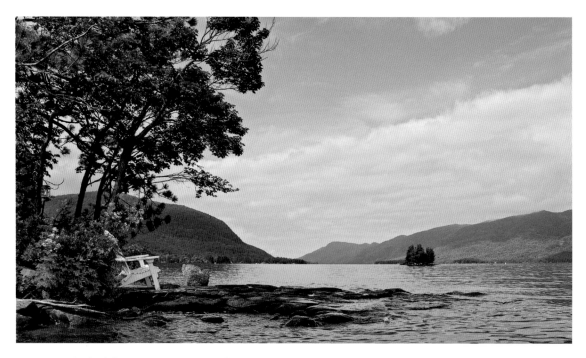

above *Loon Island and the Tongue Mountain Range from Meadow Point in the Huletts Landing area*
opposite *Anthony's Nose and Rogers Rock from the Cooks Mountain Preserve*
following page *Anthony's Nose and the Hague area from ledges on Rogers Rock*

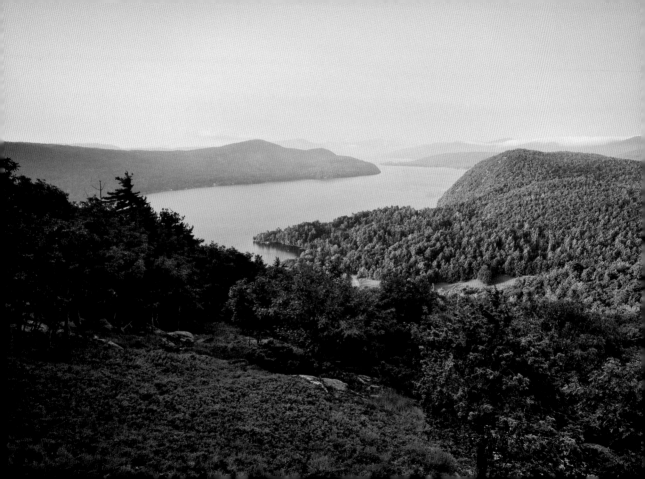

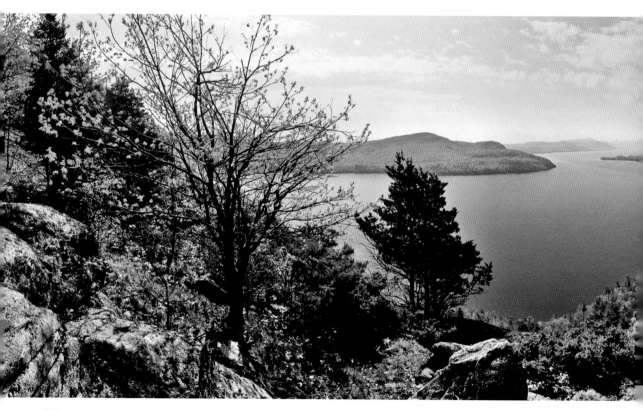

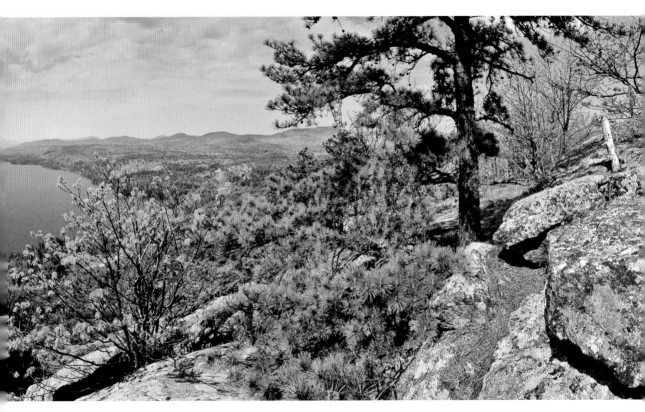

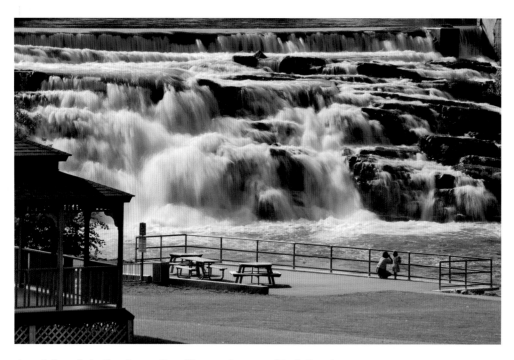

above *Falls on the LaChute River at Percy Thompson Bicentennial Park, Ticonderoga*
opposite *King's Garden, Fort Ticonderoga*
following page *Aerial view of the Champlain Valley, Fort Ticonderoga, and Mount Defiance*

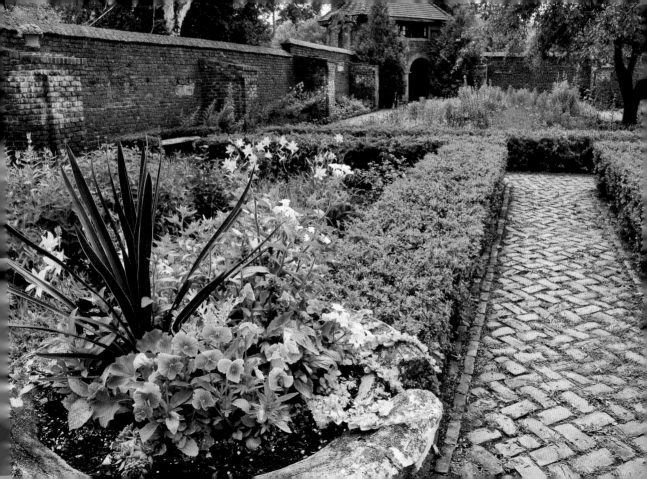

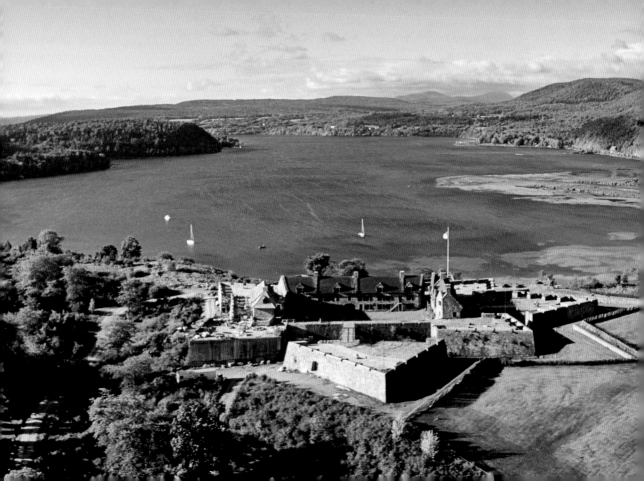

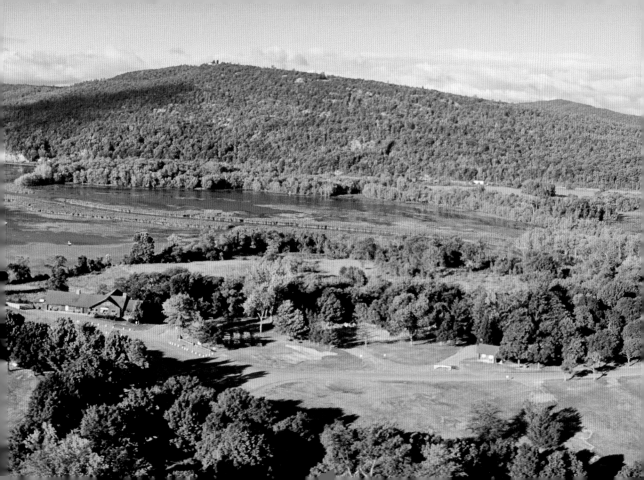

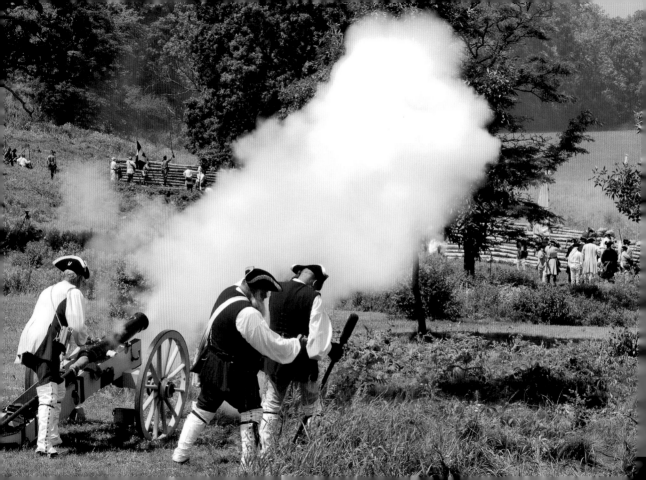

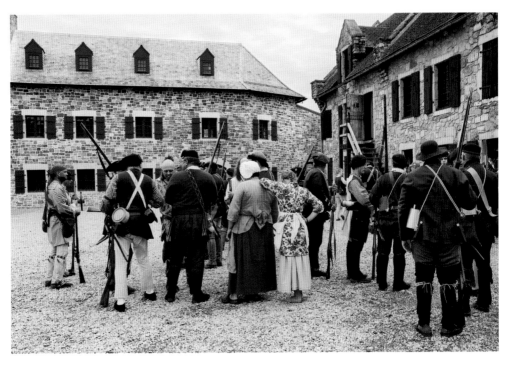

above *Reenactors on the parade grounds inside Fort Ticonderoga*
opposite *French and Indian troops attacking the British during the 250th anniversary reenactment of the Battle of Carillon*

169

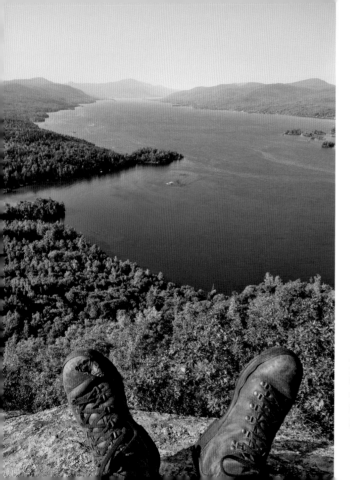

left *Looking south over Glenburnie from Record Hill by Anthony's Nose*
opposite *Aerial view of Ticonderoga and northern Lake George*
following page *Sunrise over Lake George from the Trout House Village dock, Hague*

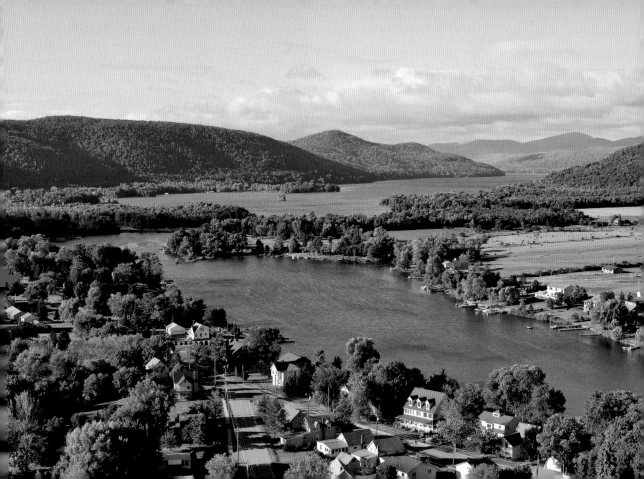

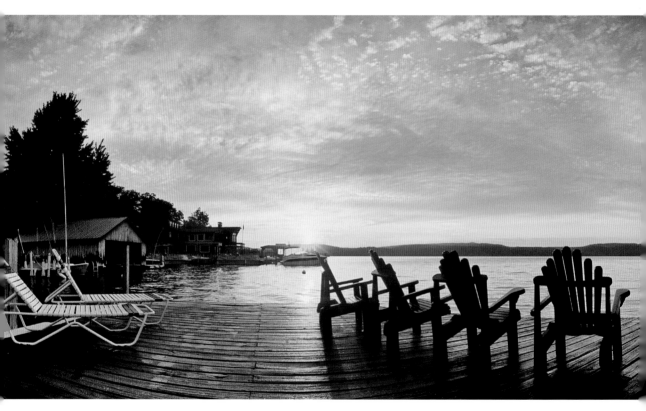

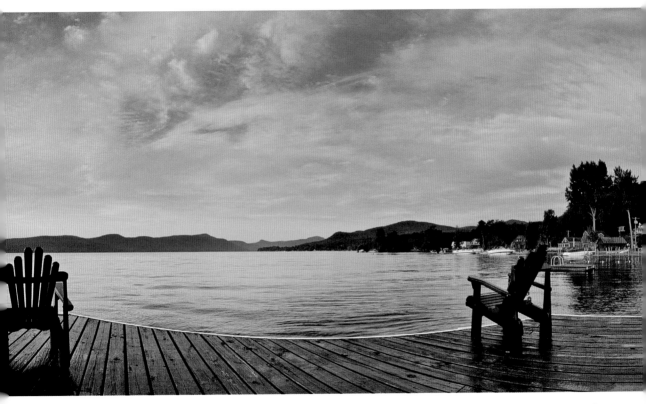

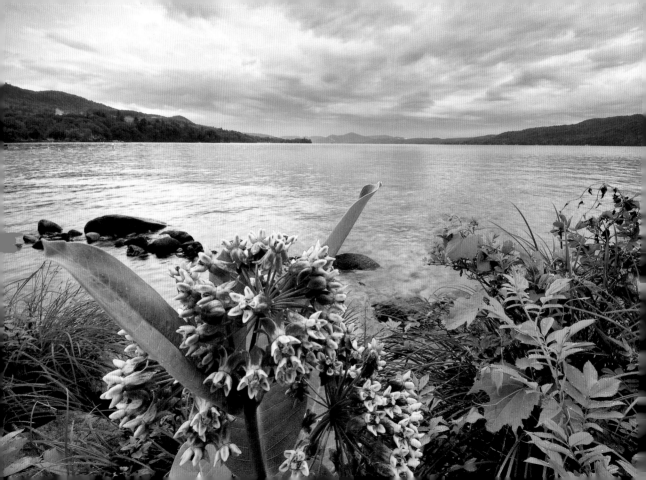

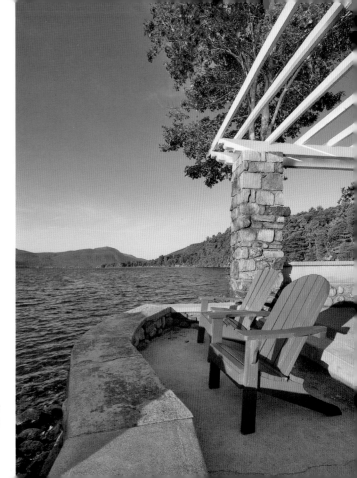

right and opposite *Views from Slim Point at the Silver Bay YMCA of the Adirondacks*

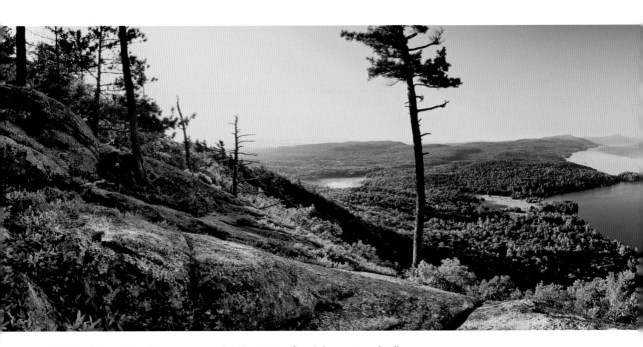

Glenburnie, Silver Bay, the Hague area, and Anthony's Nose from ledges on Record Hill

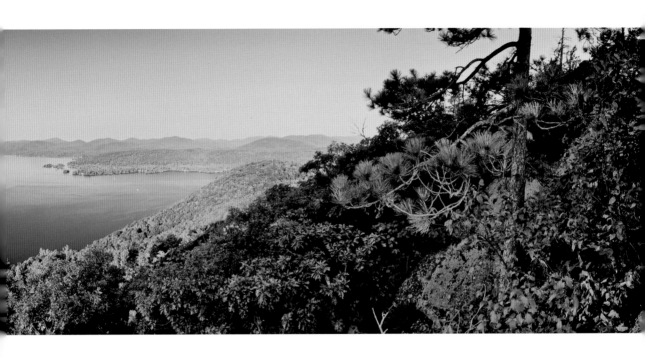

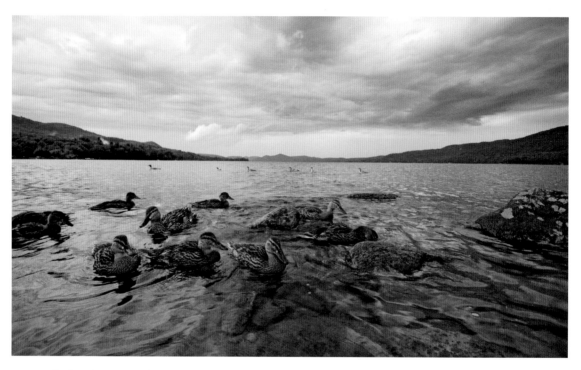

above *Mallards and mergansers after a storm at Slim Point, Silver Bay*
opposite *Toys on the Trout House Village beach*

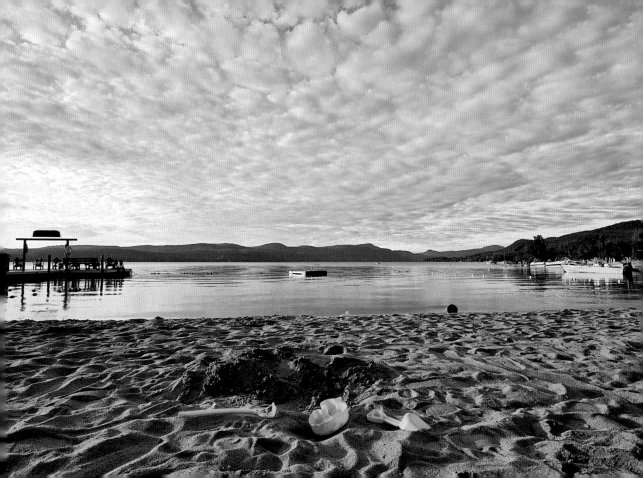

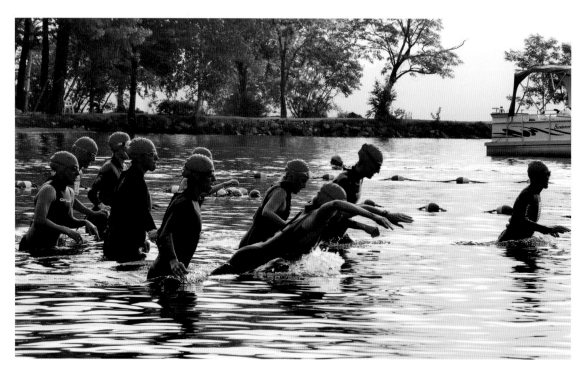

above *Swimmers in the North Country Triathlon, Hague*
opposite *A bicyclist in the triathlon on Route 9L north of Hague*

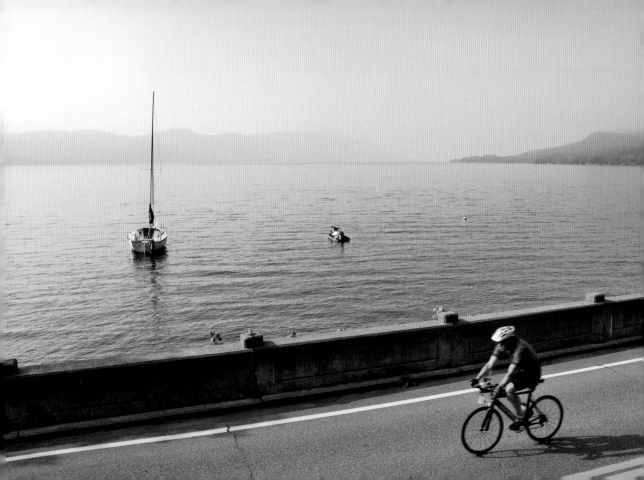

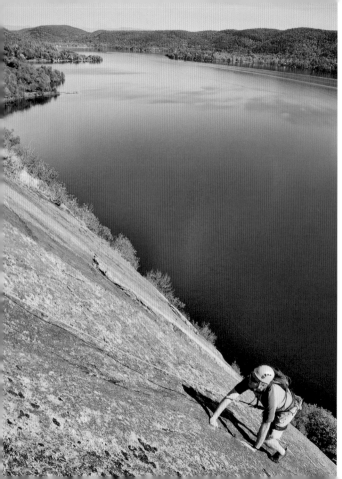

left *Climbing Little Finger on Rogers Slide*
opposite *Canoeing near Rogers Rock Campground*

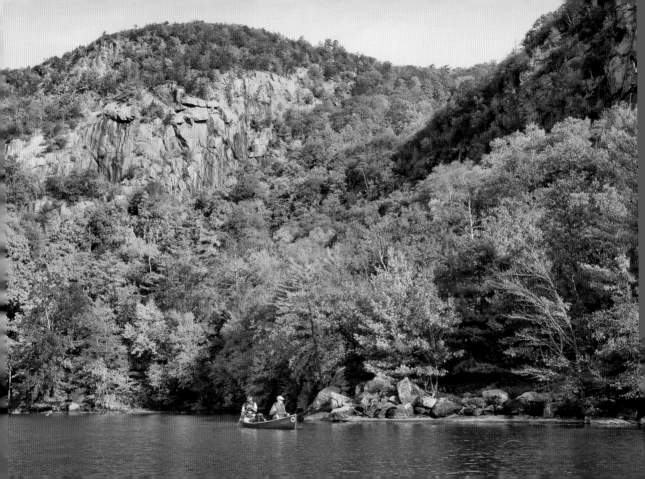

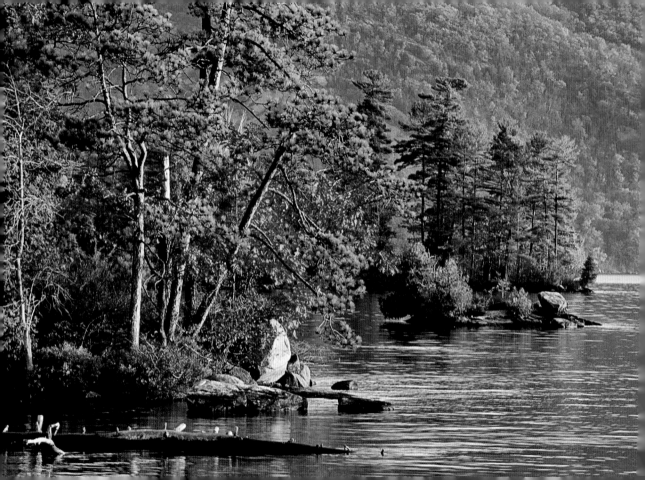

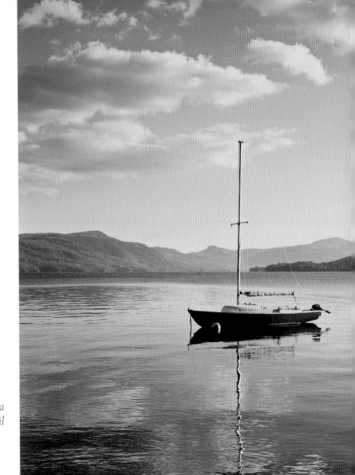

right *View south to Black Mountain from the Hague area*
opposite *Lenni-Lenape Island and Anthony's Nose detail*

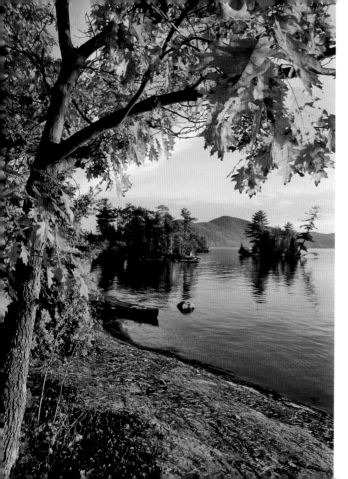

left Anthony's Nose and Record Hill from Asas Island
opposite Trout Brook, north of Hague

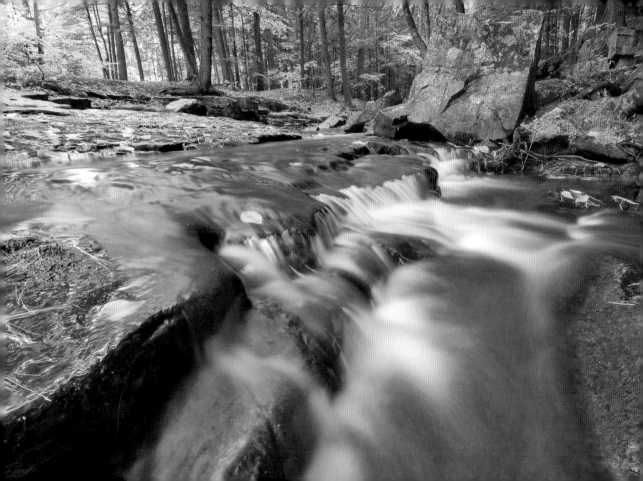

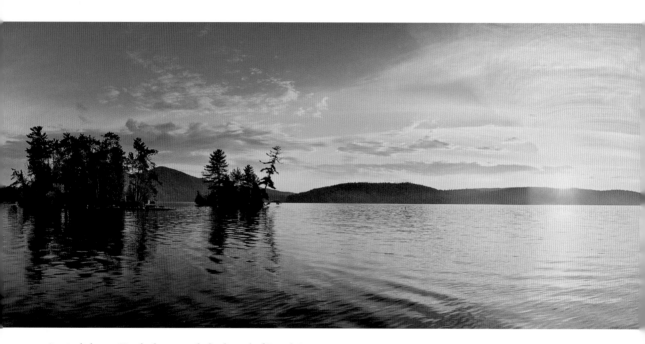

Sunrise light on a Hornbeck canoe and islands south of Friends Point

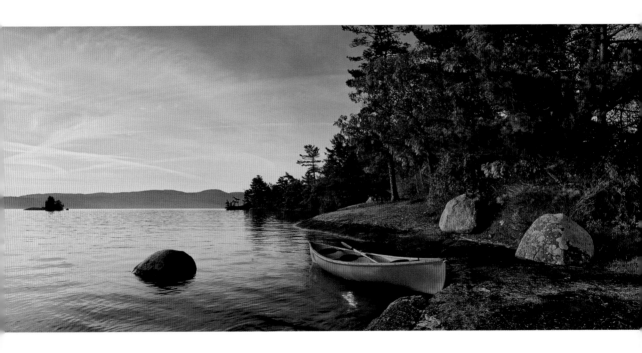

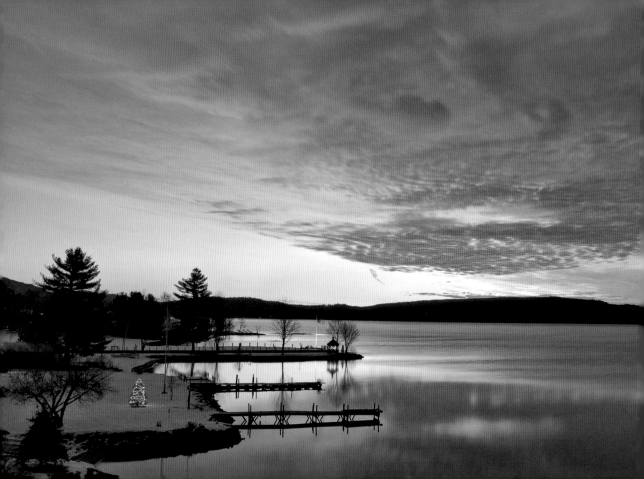

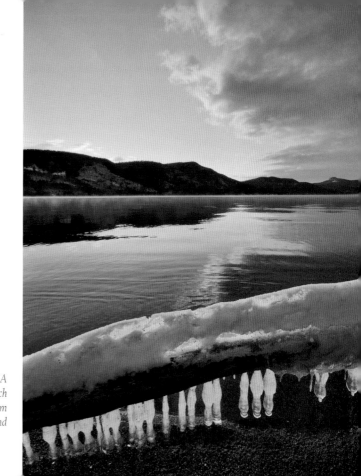

right *Icicles at the Silver Bay YMCA*
opposite *Christmas tree at sunrise near the Hague beach*
following page *Winter sunrise light from Rogers Rock Campground*

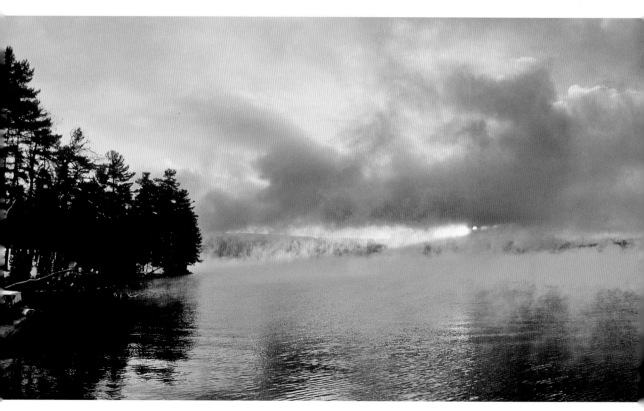

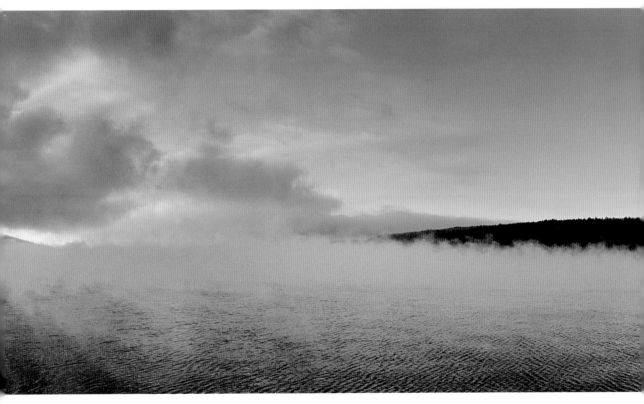

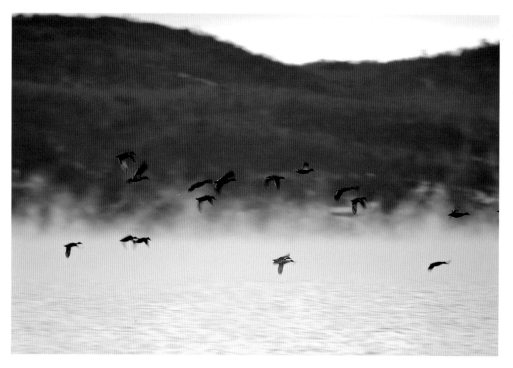

above *A flock of mallards in early morning light*
opposite *Cascades on the LaChute River, Ticonderoga*

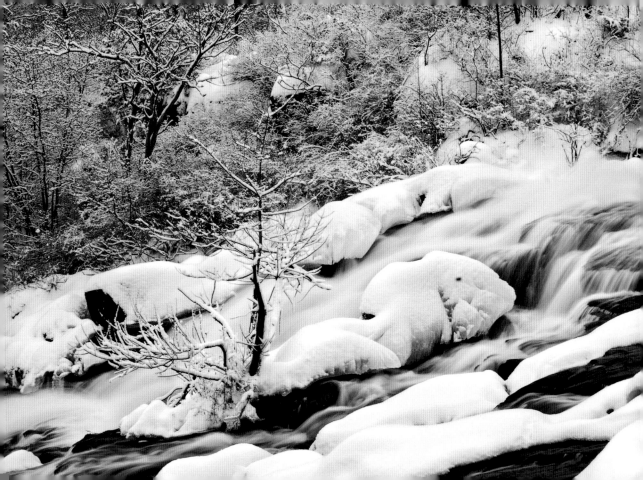

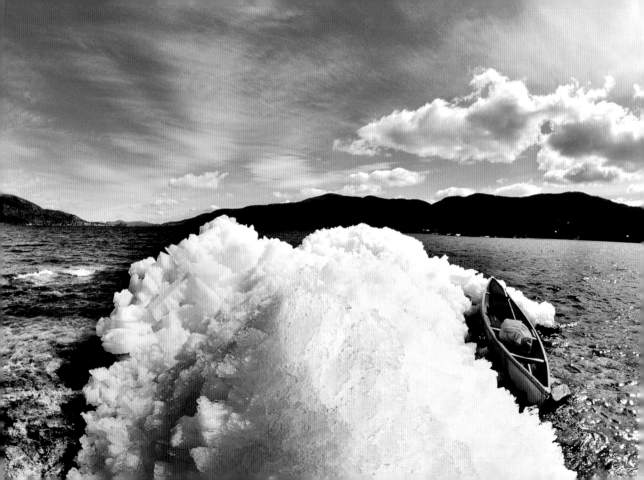

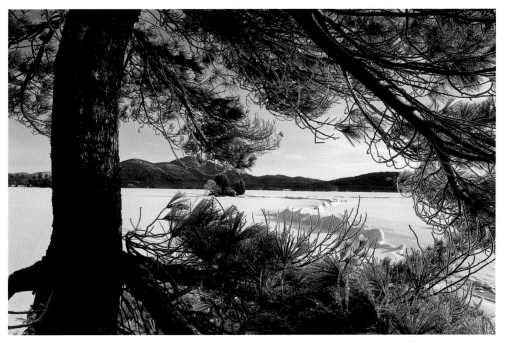

above *Anthony's Nose and Record Hill from Waltonian Island*
opposite *Ice-out near Huletts Landing*
following page *Sunrise from Rogers Rock, looking toward Anthony's Nose*

197

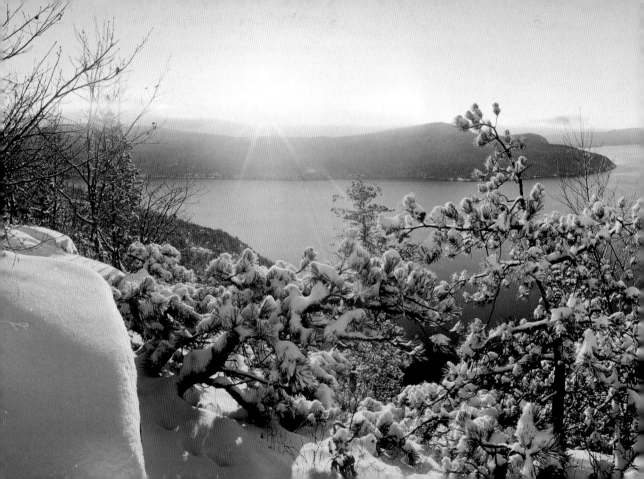